# American
# Majolica
## 1850-1900

M. Charles Rebert

*Cover: An array of signed, American majolica from the 1880s. (Top row, left to right) The Etruscan Ball Players Cider Jug; a Hummingbird plate from the Eureka Pottery Company, Trenton, N.J.; a Clifton Decor vase made by the Chesapeake Pottery Company, Baltimore, Md. (Center row, left to right) A Fern pattern jug from the Etruscan potters; a small Sunflower jug, also Etruscan; a Lettuce Leaf plate made by the Wannopee Pottery Company, New Milford, Conn.; a George Morley Fish pattern bouquet holder (in front of the plate); an Etruscan Sunflower underplate; an Avalon Faience vase, the Chesapeake Pottery Company. (Bottom row, left to right) A Shell and Seaweed lidded butter keeper, Griffen, Smith and Company; a Leaf pattern tray potted by the Tenuous Pottery Company; the Etruscan-made Shell and Seaweed cigar box.*

*Published by*

*Wallace-Homestead Book Company*
*1912 Grand Avenue*
*Des Moines, Iowa 50309*

*To Cornelia Lark Rodock and Gordon S. Weniger for the inspiration,*
*loyalty, and capable assistance they both have given so unerringly*

# Acknowledgments

My sincerest thanks are extended to the following friends who opened their private collections of majolica for inclusion in this book, and who provided so much information on the subject of American majolica. All of the credit for the fine photography goes to William Buehrle, who unselfishly gave of his personal time and artistry in providing the color section and photographic details of this book.

Cornelia L. Rodock

Mr. and Mrs. Michael Horn

Mr. and Mrs. John Boraten

ReLloyd Fronheiser, Jr.

Mr. and Mrs. Gary Duncan

Miriam Brubaker

Dr. and Mrs. Harold C. Ayres

Mr. and Mrs. Russell Custer

Mrs. F. Wallace Cornog

Mr. and Mrs. Grover Kershner

Edith M. Wachter

Mr. and Mrs. Samuel Boyd

Mr. and Mrs. Ernest H. Bellard

Howard H. Peck

Mrs. Beth C. Hampsey and the New Milford Historical Society

Jean Stamm and the New Milford Library

Joanne Nichols and the Colony House Museum

Bill Gates and the East Liverpool Museum of Ceramics

# Contents

# Preface

American majolica is an antique pottery, widely collected, vividly handsome, and little understood. It is found in abundance in most antique shops, at many antique shows, and sometimes at weekend flea markets. But try to learn something of its origin, and you will find volumes of information on the subject of 16th-century Italian majolica, the delicate Dutch delft of the 17th century, Bernard Palissy's fabulous faience of France, and even more about the rare and naturalistic masterpieces of Thomas Whieldon and Josiah Wedgwood of England in the 18th century.

Except for the publication of books dealing with American and English potters' marks by such respected authorities as Godden, Cox, Ramsey, Thorn, and others, the archives of most libraries and the booksellers' shelves have little to add to the history of American majolica. This sad injustice awarded to majolica is shameful.

But perhaps it was done with good reason. Majolica is a misnomer, it is a trade name which 19th-century potters thought added a touch of romance, or a bit of class, to their colorful wares. How the 19th century name evolved is an enigma; but its origin, at least, can be traced historically.

In the early 14th century, Spain, under Moorish occupation, exported its opaque, tin-enameled pottery to Italy aboard ships from the Spanish island of Majorca. The term ''maiolica'' was applied to this pottery as a result of the medieval spelling of the island's name. Majolica was not made on the island, but the name stuck just the same.

Today, collectors apply the name majolica to the generic classification of all mid-19th century pottery with raised designs, imitative of nature's creations, richly painted with vitreous colors and topped off with a clear, lead glaze.

This should help to set majolica apart from the early Palissy and 18th-century Whieldon and Wedgwood pottery, as well as 17th-century French faience and Dutch delft — all of which relied upon a full undercoating of an opaque-white tin glaze, whether combined with colors or not.

Another logical explanation for the absence of recorded information on the subject of American majolica is that by the height of the 1880s, majolica, at its best, was equal to the finest pewter and silverware as a suitable gift for weddings and significant occasions. But, on the other hand, at its cheapest, it was a trite and commonplace novelty. This latter situation could have been detrimental enough to turn off the better writers of its heyday. Even today, we may be too blase to the topic of majolica to generate the interest that is truly due this exciting American antique. So, the subject of majolica has almost been neglected by all ceramics writers, being, as the adage affirms, too close to the trees to see the forest.

Therefore, it is the intent of this book to offer the collector and the dealer in majolica wares as much pertinent information on the subject of 19th-century American majolica as is now possible. To attempt to cover the complete topic of 19th-century majolica would require volumes, for the English production of majolica by Wedgwood, Minton, George Jones and Fielding, alone, was astounding. So, the emphasis herein remains with the works of our emigrant potters who began in America with so little and gave us all so very much to enjoy.

# 1 An Introduction to Majolica

Whether you are an advanced collector of American majolica or a beginner, you may already have realized that the pottery you are collecting exists today only because the American public from the mid-19th century to the beginning of the 20th century enjoyed the lavish colors and almost endless rustic forms of this pottery as much as any of today's collectors. Majolica fits perfectly into our lifestyles today with the same ease that it did a century ago, explaining, in part, why it is being collected avidly from coast to coast.

The modern homemaker prizes her elegant, dolphin-footed centerpiece for its decorative value, while the lover of Early American pine or maple cherishes grandmother's Shell and Seaweed tea set in majolica as much as the family's pewter or Gaudy ironstone. For the decorator looking for accent pieces, majolica again comes forward. Should the reader be investment-minded, majolica may not be a ''sleeper,'' but its value continues to increase steadily.

Because majolica is a soft-bodied earthenware over which decorators have added their warm and earthy colors, it is reasonable to expect some wear or deterioration to show from the past hundred years of loving care or lackadaisical use. Many collectors will purchase nothing but proof pieces when adding to their enviable collections. This is marvelous if the trick can be accomplished regularly, but Lady Luck is not always so kind. A hairline, a spider in the bottom of a pitcher, a potting fissure, or a flake off the glaze need not deter its purchase if the item exhibits richness of color and otherwise sound condition. Likewise, if the offering in question is one of those rare or hard-to-find pieces with some defect, buy it. Chances are, it may not come your way again soon.

Fortunately, flakes or chips can be restored easily and reasonably by professionals; and hairlines in pottery, unlike glass, will not continue unless provoked by further careless use. What *does* reduce value is an open crack, a missing teacup handle or a lid to a sugar bowl. Crazing or crackling of the glaze on majolica is common, even on perfect, never-used pieces. Since most majolica experienced daily use, the bodies of such pieces may have darkened and colors may have dimmed, but a thorough cleaning by a professional will generally restore such majolica to pristine condition.

The cost of majolica is pretty much determined by rarity, maker, and condition. Supply is also a determining factor. For instance, pewter-topped syrups command much higher prices than do pitchers, even by the same maker or in the same design. The reason: fewer pewter-topped syrups were potted. Plates in most patterns are more common than are cake stands; so supply and competition help to establish prices.

Majolica continues to increase in value and in favor as more and more collectors join ranks in searching out the available supply of perfect or mint pieces of the ware.

Auctions, more often than not, bring higher prices (even for damaged pieces) than those asked by the average antique dealer. Chalk that one up to the fever of the bidding and the determination of the bidder!

Many majolica collectors choose to purchase only signed or potter-marked pieces. However, in doing so, many rare and excellent examples of American majolica slip through the fingers of the collector. Some of the finest majolica made in America was made to compete with and imitate the finest of the English Minton, Wedgwood, and George Jones majolica. Nearly all American potters remained competitive in the business by not signing or marking their wares, thereby confusing the buyer and offering their unmarked majolica at lower prices. Today, unsigned majolica prices continue upward as buyers realize and appreciate the craftsmanship and beauty of such pieces. True value remains, as the poet said of beauty, in the eyes of the beholder.

To help the buyer identify majolica more readily, let it be said that antique majolica generally bears a greenish to bluish white coloring on the undecorated base of the ware. In the beginning of its manufacture, the clay was pressed by hand into the plaster molds before being fired in a kiln. If all of the air had not been kneaded out of the doughy clay before firing, air bubbles often erupted during the firing, causing small pits to form. Because production costs had to be kept low, such pieces were not always weeded out. Today, such pieces of majolica generally are considered acceptable to the buyer who knows his pottery, as are those pieces with slight firing fractures or fissures caused by high kiln temperatures. Such small defects, always under the glaze, should not be confused with open, raw cracks or bruises that developed later from careless use or wear.

The potter's use of numbers or letters found on the underside of many majolica pieces, known as factory marks, helps very little in determining the origin of the majolica, as the American, English, and Continental potters used similar marks in the process of their majolica making. Such marks probably helped the plant boss or owner identify the patterns or decorators of the ware.

Most potteries employed a chief designer and a chief decorator. However, the actual painting or decorating of the majolica was left to the female employees: women, young ladies, and schoolgirls. This was yet another method of holding down production costs, for women's wages were at the bottom of the pay scale in most potteries. Except for a finished model which was prepared by the chief designer and decorator, the paintresses simply imitated the original sample. Naturally, few of them were as talented as their masters. Their workmanship reflected their skill, explaining why so few pieces of the same pattern are identical.

The practice of hiring largely unskilled and often unschooled labor was far more prevalent among American firms than among foreign potteries. Certainly this is one important reason why English majolica, particularly, is often finer in most respects than the American variety. But, wherein our American potters failed in perfection, they made up for such loss with fresh creativity, spontaneity of design, and lavish use of color.

The initial steps in majolica potting required an original mold. This was the master potter's assignment. From the designer's mold was cast a plaster mold for receiving the prepared clay. The initial clay was a doughy, tacky mass, having been mixed with water first, then kneaded, rolled, and steamed before being cut into

blocks for molding into the plaster forms. For the more technically minded readers let it be said that small quantities of china clay and ground flint and stone were added to the base clay to improve its durability and quality.

After the blocks of soft clay were forced by hand into the plaster molds and formed into the desired shapes, they were removed from the molds and put into clay boxes called saggers; the saggers were placed, one on top of the other, in tall stacks within the bisque kiln. The majolica was then given its first firing or "burning."

When this step was completed, the majolica was cooled and removed from the saggers, then each piece was cleaned by hand and sanded of raw edges. It was then time for the women and girls, who were nicknamed "the majolica girls," to do their thing. Since the foregoing process required long hours in preparation and in firing, many of the first-burned majolica biscuits were carried home by the decorators after closing hours; for even the strenuous 7 A.M. to 6 P.M. schedule did not allow sufficient time for the decorators to finish their work. Later in the evening, around the kitchen table and under the yellow illumination of kerosene and gas lights, the women and girls painted. Vitrified colors, or glossy paints, which when heated later in the kilns would turn brittle and gleaming on the majolica, were applied. Such paints or glazes seeped down into the body of the ware, producing the deep, lustrous colors for which majolica is famous.

Always working under pressure and frequently paid by the piece, the molders and the paintresses did the best they could. Some results were excellent; some were poor. Some of the majolica met with minor home accidents; some pieces were mishandled in transporting them back to the pottery. But, all in all, much survived that is beautiful.

Following the decorating process, the majolica was returned to the kiln for a final burning called glost firing. Stilt marks on the bottoms of cups, saucers, and plates are commonplace. These rough marks were made by the dividers used when majolica was stacked in the saggers for firing. Such marks are never considered flaws or damages.

A final word should be said about the glazes used by American potters. Very little American majolica received the tin glaze used in the earliest manufacture of the ware, and for very good reason. Tin had become quite expensive by the 1850s. Lead remained cheap. Besides, lead glazes gave American majolica a finer and harder finish that increased its beauty and durability.

To complete the story of the making of majolica, after the ware had been removed from the kiln for the last time, it was hurriedly checked by hand. Husky young men then packaged, crated, and stacked the majolica in warehouses where it waited to be picked up or delivered to crockery stores, gift shops, and retail outlets. The cycle was then ready to be repeated.

As pottery technology increased, less and less work was performed by hand, for industrialization brought with it the invention and use of many power-operated machines. Steam boilers provided enough energy to harness ten to sixty-horsepower engines to do the work of many laborers.

By the 1880s and 1890s many potteries relied upon engine power for operating such equipment as grinders, jiggers, lathes, and casting machines. The clay press

# American Majolica
## 1890—1900
### By M. Charles Rebert

**To the Reader:**

This first edition of *American Majolica 1890—1900* contains three production errors, which, unfortunately, were not detected until the edition was printed.

**Page 24:** Legends accompanying photographs at top left and bottom left are transposed.

**Page 65:** Center photograph of "W" mark is upside-down.

**Pages 61 and 64:** Legends of top photograph, page 61 and top photograph, page 64 are incorrectly transposed.

The author, M. Charles Rebert, a recognized authority on majolica and other valued antiques, was in no way responsible for these regrettable errors.

*—The Publisher*

alone saved countless hours of hand labor in the removal of excess moisture from the slip that was to become the clay for the molder's use.

As more and more machinery could be afforded by the pottery owner, fewer and fewer employees were required. Unemployment resulted, and with it came the formation of labor unions to protect the workers and their jobs. Strikes were frequent and often violent during the transition from manual labor to mechanization. Before 1900, many potteries had gone into production-line manufacture, assisted by machines which cast, turned, and sanded plates, cups and saucers, and bowls. A new America was emerging, an industrialized America, forging its way into a new century.

Today, 20th-century majolica is being imported from Italy and from Portugal, but such wares are easily identified by the ''Made In'' marks which never appeared on Victorian majolica. Such majolica is light in weight and designed for the modern homemaker who buys such majolica for patio use and informal indoor-outdoor entertaining.

In the 1920s and 1930s there was a resurgence of interest in European majolica. Again, such wares lack the styling common to Victorian majolica, but may be considered collectible from the Deco period of art. The current, do-it-yourself ceramics kits permit hobbyists the pleasure of making one's own earthenware for home use or for gift-giving. There are no known reproductions of Victorian majolica; so collectors need not fear collecting American majolica as either a pleasurable hobby, or for investment purposes.

# 2 Majolica in Historical Focus

The last half of the 19th century was an America coming of age. America was a heterogeneous blend of emigrants — some farmers, some artisans, and some fortune seekers. America was brawling strip miners moving hills for coal to fire the railroads of Commodore Vanderbilt and the steel mills of Andrew Mellon. America was city sweatshop laborers, mill workers, and wealthy elite who arrived here rich or who quickly acquired a share of America's new fortunes. It was an era of hazardous destruction of our natural wealth, a time of acquiescence for an indigent middle class amid the opulence of New York's wealthy 400 whose Midas touch turned manpower into mansions and money into millions.

Mingled into it all was a warmed-over, puritanical narrow-mindedness of a society besmirched by vulgarity. Political autocrats and the wealthy elite offered either token patronage or nothing to the struggling artists America was producing. Much that was produced artistically was an inbreeding of borrowed creations executed for commercial gratification. For posterity, the affluent families stripped Europe's castles and courtyards of their finery and art treasures and called it fabulous fortune as they added borrowed masterpieces to their marble mansions.

Into the middle of this melange of rampant growth and bourgeois social order was born a new ceramic art form called majolica which was destined to become America's fair-haired prodigy. The Victorian days of ''father knows best'' were ripe. All that was needed was a ceramic imagination!

Prior to 1850, most American housewives and innkeepers had to be content largely with English imports of dishes, cups and saucers, and all the tablewares vital to the homes and eating places of the day. Homemakers found little else in the merchants' shops than the usual Staffordshire blue and white pottery, especially the Blue Willowware pattern. For the everyday housewife it was the white line of ironstone china, heavy, cumbersome, and drab. Sponge and spatterware helped on occasions. For the more affluent there was Chinese export; for others the option was English lustrewares. The time, indeed, seemed perfect for a creative and colorful change.

Herbert Minton, the now-famous Victorian potter of Stoke on Trent in England, introduced at the Crystal Palace Exhibition of 1851 a color-glazed earthenware collection, imitative of the finest Italian majolica of earlier times. He called his collection ''majolica,'' and potting history was made. True, Minton's first pieces were decorative examples — architectural ornaments, tiles, flower vases, jardinieres, and candlesticks. Utilitarian pieces were yet to come, and as they did, orders for Minton majolica began crossing the Atlantic.

The great and venerable Wedgwood factory in Etruria was not to be outdone by Herbert Minton. By 1860, Wedgwood began offering the world a complete dinner

service in their first version of Shell and Seaweed majolica. In no time, this bright and beautiful majolica was on its way to America, much to the delight of American housewives and innkeepers. The price for this new, utilitarian dinnerware was right. Most families could afford it; it was reasonably priced, but never cheap.

Within this same historical framework many trained and competent emigrant potters from England and the Continent were finding employment in potteries along the East Coast. Many found work in the growing potteries at Bennington, Vermont, and Jersey City, New Jersey. Others began their careers in the smaller potteries at St. Johnsbury, Middlebury, and Dorset, Vermont; a few more adventurous ones traveled westward into the Ohio Valley. It proved to be only a matter of time before these emigrant potters would pit their potting skills against their contemporaries back home.

In its embryonic beginnings, majolica was a novel change in the appearance of earthenware — a far cry from the yellow and redwares that had been traditional. Majolica was bright and colorful; it was figured and fetching. It was charmingly different. Above all, it was perfect for the dandy sense of Victorian decoration and taste.

As the trend caught on, homemakers found more and more majolica to their liking. A real-as-life begonia leaf could become a majolica pickle dish! A milk jug could be mistaken for a miniature oaken barrel. And for the dinner table, what could be more exciting than lavender-centered, blackberry-bordered plates with cups and saucers to match? Now *that* was different!

The American public took to imported English majolica in increasing numbers and in the 1860s and 1870s exhibited a growing appetite for more and more majolica which the English potters were happy to oblige. It was not until the Great American Centennial Exposition of 1876 that American majolica gained its rightful recognition, thanks to the outstanding exhibits of such potters as James Carr, proprietor of the New York City Pottery, Edwin Bennett of Baltimore, and Joseph Mayer of Trenton. Most crockery buyers, the tradespeople, and the great American public acclaimed the new American majolica fantastic, and every judge agreed.

By the height of the majolica age in the 1880s, the American marketplace overflowed with realistic renditions of Bamboo luncheon plates, Ocean-Shell bowls, Pineapple cups and saucers, and Ear-of-Corn pitchers. It was the age of invention, rampant growth, vibrant colors, and, in the case of majolica, it was nature artistically captured and confined in the potters' mold.

Out of the midst of this almost frantic endeavor came much of the fine Wedgwood-like majolica of the Chesapeake Pottery Company, which D.F. Haynes of Baltimore called Clifton and Avalon. Griffen, Smith, and Hill of Phoenixville, Pennsylvania, built a potting empire largely upon their output of Shell and Seaweed majolica. In Wellsville, Ohio, Morley and Company produced some of the finest napkin plates and figural pitchers to be found anywhere. The New York City Pottery Company, founded by James Carr, turned out examples of Shell and Seaweed that rivaled both the Wedgwood line and the famous Etruscan rendition of the same pattern.

All in all, there mushroomed into existence an estimated six hundred potteries in America, and the majolica market became a highly competitive venture. Except for a handful of potters, no one marked or signed his majolica. Only the giants of the business — Etruscan majolica, made by Griffen, Smith, and Hill of Phoenixville, Pennsylvania, and Clifton and Avalon majolica, manufactured by the Chesapeake Pottery Company of Baltimore, Maryland — clearly signed and marked their wares with identifying imprints. Others, like Morley and Company of Wellsville and East Liverpool, Ohio, Wannopee Pottery Company of New Milford, Connecticut, and in Trenton, New Jersey, Charles Reynolds, producer of Lettuce Leaf majolica, signed some of their output. Increasingly, majolica came onto the market unidentified as to maker or origin.

And, from a business point of view, most American potters thought it the best way to compete, pricewise, with both the English imports and with the few large American potteries. When it is considered that an imported Wedgwood majolica pitcher was selling at $.75, why not copy it, leave it unmarked, and undersell it by $.25? So it went for many small potters who never marked their majolica wares, but offered the crockery merchants fantastic bargains, such as teapots for $.45. The merchants in turn, probably priced them at $.75 for retail trade. Cuspidors were wholesaled at $.40 each, cake stands at $.65, card trays for $.15, dinner plates for a penny each, and cups and saucers for $.15 a set. But recall, also, that laborers' wages were around $2 a day.

Even by underselling the competition, small potteries generally made small profits and, in most cases, remained small in plant size, operating largely with family help and local laborers.

Majolica making was often a part-time business, sometimes a summertime occupation for migrant or journeymen potters. In the final resolution, it was left to the fortunate few to grow successful and prominent in the business of potting majolica.

The greatest sales impetus to the majolica movement came in the mid-1880s with the introduction of premiums that were given out by countless city and village grocers to stir interest in such products as Price and Company Baking Powder and Mother's Oats. Even without a modern public relations department or a slick Madison Avenue advertising campaign, housewives the country over — who were no different from today's coupon-clipping homemakers — bought the baking powder and oat cereal and collected the coupons. In return, more and more majolica found its way into the American home and marketplace.

By far the greatest production record was set by Griffen, Smith, and Hill, a late bloomer in the majolica business, but almost overnight the giant of the trade in the 1880s. When the Great Atlantic and Pacific Tea Company chain signed Griffen, Smith, and Hill as their suppliers of majolica in their premiums-for-majolica sales campaign, they hit the jackpot. So did Griffen, Smith, and Hill!

Several factors led to the ultimate demise of the majolica market. One factor certainly came from within the majolica industry itself — overproduction. Another factor was labor unrest. The economic conditions of the 1880s verged on a serious depression as workers sought better wages and working conditions. The owners of industry seemed unable to mediate with unionized labor after so many years of dictatorial rule. Strikes were often long and violent. Added to these factors came

the fickle change in the public's taste for newer things, such as Art Nouveau, Tiffany, and bone china. And still, England and Europe kept shipping us more and more majolica.

By 1900, majolica had all but disappeared from the shelves of such fine stores as John Wanamaker of Philadelphia and Marshall Field of Chicago, as well as the corner dry goods store. It remained for another generation, a century later, to rediscover the best of majolica and collect it as an antique today.

# 3 The Brothers Four

James Bennett, born in 1812 in Newhall, England, emigrated to this country in 1834 and found employment in the Jersey City Pottery, located in Bergen, New Jersey. After five years, Bennett decided to try his luck independently as a potter and moved west to the East Liverpool area of Ohio, where he found clay suitable for the manufacture of yellowware. Here, in 1839, James Bennett founded the first pottery in an area that was destined to become one of the country's largest centers of the pottery industry.

Bennett met with quick success in the production and sale of $250 worth of yellowware and immediately sent for his three brothers — David, Edwin, and William. The three Bennett brothers, all potters, arrived in East Liverpool, Ohio, five months later. Together with James, they formed the firm of Bennett and Brothers.

For the next three years, the four Bennett brothers produced much yellowware, but their specialty came from the introduction of the first Rockingham ware to be manufactured in this country. Wholesale crockery merchants from Louisville, St. Louis, Cleveland, and Cincinnati bought most of their output.

Soon it was time to expand their business, and the Bennetts decided to move into the Birmingham area of Pittsburgh, Pennsylvania, where better coal and cheaper transportation were available. In 1845, they opened a large pottery there, and the following year entered samples of their wares in the American Institute Exhibition in New York, as well as in the Franklin Institute Show in Philadelphia. Their exhibits at both competitions won them silver medals and highest recognition, as judges declared the Bennett wares to be superior and finer in every way to similar English imports.

In 1846, Edwin Bennett withdrew from the firm and moved to Baltimore, Maryland, where he would soon become the founding father of the American majolica industry. James Bennett continued on in the pottery business in Pittsburgh and died there in July 1862, at the age of fifty.

## Edwin Bennett

Edwin Bennett found lodging in Baltimore and immediately began his search for a suitable clay for the pottery he hoped to build there. His search became a reality that same year when he erected a small pottery on Canton Avenue. Just as his brother James had been the first man to build a pottery in the East Liverpool area, Edwin became the first to build a pottery south of the Mason-Dixon line. The first Maryland-made yellowware, stoneware, and graniteware began to find immediate acceptance among the crockery merchants of Maryland and nearby Pennsylvania.

Two years later, Edwin was joined by his brother William in the business. Together they founded the now-famous pottery, E and W Bennett, which would soon make majolica history in America.

The brothers experimented with clays and with glazes, and their hopes increased for a new introduction to their line of standard crockery. What they did succeed in producing was a Rockingham-type teapot which they christened "Rebekah at the Well." It bore a tortoiseshell surface and a high-relief image of Rebekah, with her water jar, on both sides of the teapot, which was richly mottled in custard and russet colors, with a fine, hard glaze that provided a warm depth of sheen. The teapot became the envy of every American potter and was widely copied, but never excelled in quality. Thanks to Bennett's chief modeler, Charles Coxon, the company went on to introduce the "Wild Boar Pitcher" and the "Stag Hunt Jug." The "Stork" pitcher and many more notable and innovative forms have been credited to the E and W Bennett Company. The time was 1850–1853.

True, the Bennett brothers were encroaching on the sacred potted specialty of Norton and Fenton in Vermont, and the Bennington boys scowled at these upstarts. What else was new? Hadn't the Bennington firm copied English Rockingham ad infinitum and vice versa? There appeared to be room for more, and the competition grew a bit keener.

In their experimentations, the Bennetts found a way to apply vitreous colors under a clear and hard lead glaze that brought the high-relief portions into focus, thus adding more importance to those areas. Using a white clay, Edwin Bennett molded a bust of George Washington, as well as a sage-green marine pitcher with a griffin handle on a body of a swimming fish in high relief.

This new, experimental earthenware with its clear, vitreous colors and high-relief molding was introduced to the public as "majolica" in the mid-1850s. America had its first look, and acceptance was immediate. The timing, too, was perfect, for Herbert Minton had just introduced his own majolica collection at the Crystal Palace in London. News crossed the Atlantic that America had its own majolica creator — Edwin Bennett — and the buying public took note enthusiastically.

Edwin followed this success with a pair of mottled majolica vases, twenty-four inches tall, with lizard handles and high-relief grapevine decoration. Perhaps even more important was a large, three-foot tall majolica jardiniere decorated in robin's egg blue, lemon, and mottled colors. Bennett subsequently went on to produce octagonal majolica pitchers, coffeepots, syrup jugs, and serving pieces in this brand-new line of majolica. And he did so twenty years before most other American potters could pronounce the word.

Brother William retired from the firm in 1856 because of failing health, but Edwin went on to greater heights. He experimented in faience — that generally smooth-bodied majolica decorated with scenes and natural subjects such as butterflies, birds, and animals in full color under the glaze.

In the 1890s Bennett revived the Old English method of slip decoration in which the designs are painted in tinted, liquid clays over a green clay body and covered with a clear glaze. This ware became known as Albion and required a high degree of artistic competency. Today such examples of Bennett's work are known as art pottery. In 1894, Bennett began producing Brubensul ware, a highly glazed

majolica, painted in combinations of dark and light brown shades. This ware found its greatest acceptance when reserved for large jardinieres and pedestals suitable for supporting important busts and large figures.

Much of Bennett's success in later years came from the artistic services of two renowned decorators — Kate DeWitt Berg, his chief paintress and a graduate of the School of Industrial Art of the Pennsylvania Museum, and her assistant, Annie Haslam Brinton, also of Philadelphia.

Before Edwin Bennett was ready to retire in 1895, he had already served as president of the United States Potters' Association, had been acclaimed the father of American pottery and majolica manufacture, and had reared a potter-son — Edwin Houston Bennett — who succeeded him as head of the newly merged companies of Messrs. D. F. Haynes and Bennett and Company of Baltimore. In 1908, at the age of ninety, Edwin Bennett, America's renowned potter for sixty-one years, died in Baltimore, Maryland, leaving behind a wealth of accomplishments and credits that few potters could ever hope to equal.

# 4 Potter Par Excellence

James, Carr, born in Hanley, England, in 1820, was destined to greatness. Whether he lived long enough to realize his fame among American potters is dubious, for greatness is seldom bestowed upon the living. Within the history of ceramics, with which this book is concerned, only James Carr and Edwin Bennett of Baltimore today share equal status as the fathers of American pottery, specifically American majolica.

Carr's potting career began at the age of ten in England, but his American debut came in 1844 when he arrived in this country bringing with him a financial fortune of three shillings! Fortunately, Carr found immediate employment with the American Pottery Company of Jersey City, New Jersey. The starting wage for this twenty-four-year-old emigrant English potter was $1 for a twelve-hour workday. Hardly a survival wage, even for the 1840s.

As Carr worked his way up the pay scale during his eight years of service to the Jersey City firm, he labored with many potters who would, like himself, become prominent in their field. He observed, listened, and learned many of the skills that were to set him apart from the mass of potters who proved less creative and less talented.

In 1853 James Carr, in partnership with a Mr. Morrison, opened the New York City Pottery and began operations with the manufacture of white and granite wares. Although such crockery more than paid for expenses, Carr was already far more concerned with the improvement of glazes and bodies, as well as the various effects of different fuels required in the firing process. He began experimenting, and, in his search for solutions and improvements, he induced a number of fine painters and modelers to join with him in his quest for excellence. Quality and artistry were but two of the several objectives he and his staff were dedicated to.

In 1871, the partnership of Carr and Morrison was dissolved, and, for a short while, Carr specialized in stone china and sanitary wares, both decorated and undecorated. But, as Carr continued with his experimentations, he became one of the first American potters to develop the process for majolica making. By the time the American Centennial Exposition came along in 1876, he and his staff were ready to enter an exhibit of their several wares, including a large collection of his majolica.

For the first time, the American public experienced a rare opportunity to see, firsthand, the Carr-styled majolica. Included were pitchers, match boxes, a variety of vases, sardine boxes, comports and centerpieces, as well as a number of large pedestals which Carr used to support a grouping of his parian busts of eminent statesmen and famous figures. For his endeavors, he was awarded highest honors for the excellence and quality of his work.

The next year the American Institute in New York also honored him for excellence in the manufacture of pottery. This was followed in 1878 with further national recognition by the Institute for his contributions to the American pottery industry. Such singling out for acclaim became a milestone approached by few other potters of his day.

The same year, 1878, Carr was again ready to enter a collection of his wares in the prestigious Paris Exposition. At this international pottery exhibition, Carr, again, was honored with several awards for the quality and excellence of his workmanship. The Pennsylvania Museum in Philadelphia once owned a Cauliflower teapot in the traditional greens and creamy whites which was entered in the French exposition of that year.

From a perspective of time, Carr's majolica preceded Etruscan majolica (Griffen, Smith, and Hill) by at least five or six years and Chesapeake majolica (D.F. Haynes) by seven years, leaving only his contemporary, Edwin Bennet of Baltimore, as his predecessor in the manufacture of American majolica.

In addition to the Cauliflower pattern in majolica which won Carr such high praise in Paris, he also offered the public a line of majolica dinnerware in the Shell and Seaweed pattern that was somewhat similar to the Wedgwood pattern of the same name. Carr, however, favored rainbow-tinted seaweed, and shells edged with yellow, pink, and brown, which sets his version apart from either the Wedgwood or the Etruscan styling of the pattern.

In marking his majolica, when it was marked, Carr employed his monogram to identify his wares. Collectors should not confuse this monogram with that of George Jones, his contemporary in England, who used to mark a great deal of his majolica.

Carr purchased the International Pottery Company in Trenton, New Jersey, in 1879, and organized it into the Lincoln Pottery Company. Then, with Edward Clark, an emigrant potter from Burslem, England, he formed a partnership and began producing cream-colored wares and white granite. A few months later the firm was purchased by Burgess and Campbell who renamed it the International Pottery Company. Carr then returned to the New York City Pottery.

After thirty-five years in the pottery business, James Carr closed the New York City Pottery in 1888, sold the establishment, and reinvested his financial gains in rental properties on West Thirteenth Street. His retirement lasted sixteen years before he died on January 31, 1904 at the age of eighty-four.

Few potters excelled Carr in any media in which he chose to work or in the styling and decoration of his wares. The Pennsylvania Museum in Philadelphia once housed a fine collection of Carr's pottery, including majolica, parian, white granite, blue glazed ware, painted plaques, and pate-sur-pate work. Contemporaries of Carr who have written of him have identified him as a self-made man, a man of enormous energy and resourcefulness, and a perfectionist. Certainly he was a model for many young potters of his day who learned from him or who admired the man from afar.

# 5  Hampshire Pottery

James Scollay Taft was born in the remote hamlet of Nelson, New Hampshire, in the year 1844. There he grew up in those lake-scattered backwoods, northeast of the town of Keene, the hub of commerce and industry for the area. In 1871, when Taft was a young man of twenty-seven, he and his uncle, James Burnap, from Marlow, New Hampshire, purchased a former clothespin factory on lower Main Street in Keene, after finding the fields nearby abundant in rich, blue clay deposits and white silicas. The site seemed perfect for a pottery. It was less than ten miles from Troy, where supplies of feldspar and clay, especially suitable for the potting of ceramics, were available.

By early October 1871 the two men were prepared and anxious to fire their first kiln which was stacked high with an array of clay flowerpots. Whether they were too zealous or whether they increased the fires too fast is not known, but, tragically, their newly acquired factory, their kiln, and its contents went up in smoke, a total loss. Evidently their hopes and aspirations did not succumb to the same fate, for within nine weeks they rebuilt the potting shed and the kiln and recommenced their potting of earthenwares.

This time Taft included some stone jars and molasses jugs along with a batch of flowerpots, soap dishes and milk pans in his firing. Everything fared beautifully this time, and the young potters were finally on their way to serving the farmers and the community with fine crockery at fair prices. Taft was to face other setbacks and other disastrous fires during his potting years ahead, but none so damaging as his first catastrophe.

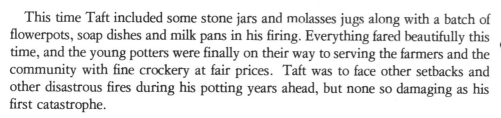

While Taft was succeeding on lower Main Street, Messrs. John W. Starkey and Oscar J. Howard, predating Taft by five months in the enterprise of pottery manufacture, were employing forty hands in their pottery south of Water Street. Starkey and Howard potted all kinds of earthenwares, applying the popular, rich brown Rockingham-type glazes to dress up their products. Stoneware was popular in the area, but to manufacture it required a lasting supply of kaolin, a pure white clay, which was available then largely from New Jersey. A wagon train could make the long and arduous trip over coach roads only during the dry, summery days; so stockpiling of the material was a necessity if the pottery were to operate during the winter and spring months. Whether this undertaking proved too taxing or too expensive, or whether inexperienced management turned the wrong corners is not known. But soon after June 1872, the partnership of Starkey and Howard declared bankruptcy and the plant fell under the auctioneer's gavel.

Taft bought the plant at the auction, and, with the purchase, doubled his capacity to produce more milk jars and jugs to the farmers' specifications and to offer better pitchers and finer flowerpots for the shops and customers of the town. Taft was evidently a good businessman with an eye for opportunity and an impulse to try

innovative ideas. As news traveled to Keene about the new pottery called majolica, which was already in great demand in Boston and New York, Taft took immediate notice. In 1878 he fired his first piece of majolica, and soon afterward offered a full line of majolica wares.

From its very inception, Taft's majolica exhibited unusual creativeness and spontaneity of design. Besides his pitchers and vases with raised figures and high-relief decorations, Taft introduced a charming and most decorative, lidded marmalade server in the shape of a juicy-ripe orange. As far as is known, this was the first and only American-made, orange-pattern piece of majolica. Its sale in the gift and ceramic shops went extremely well, for supply houses as far away as Boston began placing orders for it. Taft also favored the Greek and Italian styles in his creation of pitchers and vases for the more sophisticated shops and customers.

Never out of touch with his environment and farmer friends, Taft also began to produce a fine array of majolica jugs and pitchers in the Ear-of-Corn pattern. Using the realistic color of golden yellow for the ear of corn combined with tender green shoots of fresh leaves that wrapped themselves around the ear and formed the handle, the result became a novel, if not engaging, ceramic favorite.

Taft's finest creation was his tea and dessert set, for which he chose the New England aster as his design. Using an off-white, textured background, he allowed the delicate pinks and blues of the wild aster to burst into full bloom across the centers of plates and saucers and along the sides of teacups and teapots. Few American patterns can rival the artistic beauty of Taft's tea set when seen in pristine condition. This introduction was a major contribution, and with its graceful cake standard, the service became an important offering. Today's collector covets it as much as its first proud owner did. Taft went the whole way with this pattern, even including a handsome moustache cup and saucer for the gentleman invited to tea or dinner.

The Hampshire Pottery was indeed fortunate to have in its employ a master

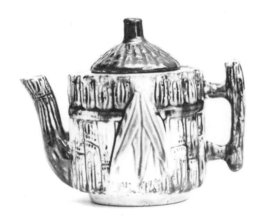

*A small Bamboo teapot decorated in natural tan colors. A three-leafed twig of bamboo adds yet another Oriental influence to this Taft-made piece of majolica. Courtesy of the Colony House Museum of Keene, New Hampshire.*

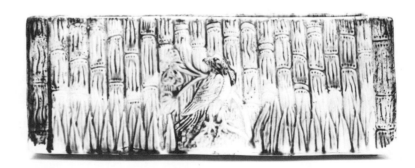

*Taft fashioned yet another Bamboo success — a planter for the windowsill. The decoration was done in the golden bamboo coloring and enhanced by a row of spearlike leaves along the base. Courtesy of the Colony House Museum.*

designer and potter, Tom Stanley, a talented Englishman who had brought with him many new and novel ideas. It was Stanley who created much of the unusual Taft majolica, shaping it by hand or on his potter's wheel.

By 1883, business was booming and Taft added a new kiln to his establishment. Then came a new department for finishing decorative pottery. He was successful in securing the master services of Wallace L. King, a recognized and respected portrait and landscape painter, to head his new department. King trained a select and talented group of young women to assist him in the decorating of majolica and art pottery. The introduction of ''artistic'' pottery was soon to take eminence over the slackening trade in majolica. New and graceful patterns in vases, rose bowls, trays, tea sets, and fancy jars began to appear in shop windows and on department store shelves. Ms. Eliza Adams, one of the more talented paintresses, was allowed to sign her initials, E.A., on her ceramic accomplishments.

Although most of Taft's majolica was sold unmarked, in later years several different identifying marks appeared. The most common was an incised ''James S. Taft & Co., Keene, N.H.,'' followed by ''J.S.T. & Co., Keene, N.H.,'' and ''Hampshire Pottery,'' reduced in some instances to the simple initial, ''H''. As Taft branched out into his newer lines of artistic pottery, more and more of his wares bore the popular Taft markings.

In the early 1900s Taft hired his brother-in-law, Cadmon Robertson, as plant superintendent. Robertson not only fulfilled his duties as plant manager, but also developed many original ceramic patterns and created the famous mat glaze which was to become a Taft trademark. Robertson created a series of variously shaped bowls, many vases, candleholders, and fine lamps. He favored the use of delicate shades of red, blue, green, and brown for his creations. Many of the Robertson-designed pieces were marked with an ''M'' inside the larger initial ''O'' in tribute to his wife, Emmo, who assisted the firm by managing the local showroom where the pottery could be seen and purchased at retail. Following Robertson's sudden

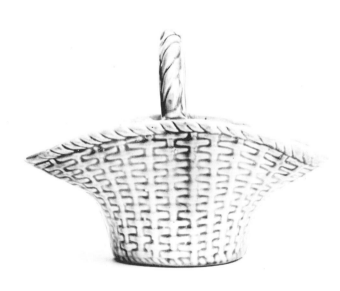

*A rare flower basket, exemplary of the fine Taft workmanship. The wicker body was glazed in bright yellow, while the handle of leaf plaiting received a green glaze. The interior was pink-washed. Every bit the equal of the Etruscan basket (Number G-2). Courtesy of the Colony House Museum.*

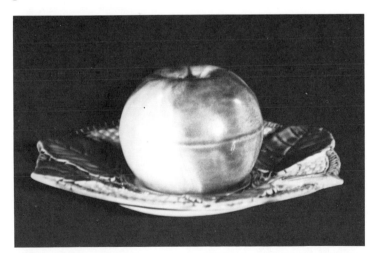

*A unique piece of American majolica. Might be attributed to Taft since he is credited with the only American-made jam pot in the shape of a ripe orange. The ripe, red and yellow apple lifts off this item to reveal a toothpick holder affixed to a leaf tray, decorated in matching yellow with green highlights. Unsigned.*

death in 1914, seventy-year-old James Scollay Taft sold his business to George Morton of Boston, who had been employed by the Grueby Company of Boston, manufacturers of decorative faience.

So, another major pottery became history, leaving behind a dusty sheaf of records, but, more importantly, an abiding presence of its existence — the beautiful Taft majolica and Hampshire pottery preserved in private collections and museums today.

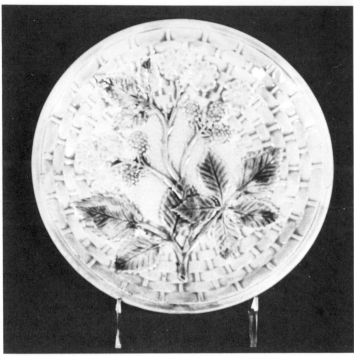

*Equally rare is this dolphin sweetmeat server. Most imitative of the Etruscan L-2 "Dolphin Comport," but smaller. The pale green shell, with pink interior, is held in balance by an aquamarine dolphin with a yellow nose. No signature.*

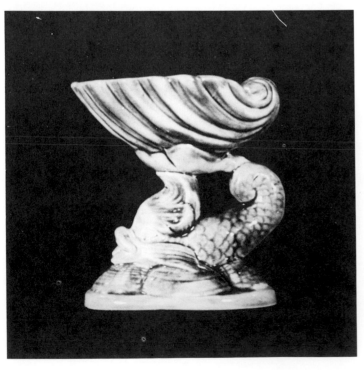

*Two unsigned, Corn pattern renditions. The statuesque teapot received the traditional golden yellow and green treatment. The smaller jam pot received the same, but with a dimpling of the corn kernels.*

*A typical American version of the Blackberry pattern shown here in a full-size dinner plate. The wicker or basket weave background was decorated in turquoise blues; while the blackberry blossoms, in pale pink, contrast well with the ripe and semiripe berries. The deep yellow center emphasizes the collective colors. Potter unknown.*

# 6 The Buckeye Potters

After the Ohio River leaves the state of Pennsylvania, it turns south at East Liverpool, Ohio, and begins its curved journey toward the mighty Mississippi. Extensive deposits of kaolin and clays suitable for the potting of ceramics were discovered very early in the 19th century along the riverbanks from East Liverpool south to Wellsville. Emigrant English potters, searching for permanent homes and suitable sites to pursue their craft, began settling in this area soon after its founding in 1799. The English first erected their kilns in the vicinity of East Liverpool and settled down to the business of potting household redware, utilitarian crockery, and builders' drainpipes.

The westward migration of the 1840s brought many hardy pioneers down the Ohio River to the potters' doorsteps, and a steady market for their wares sprang up. Flatboats following the river stopped for regular supplies of crockery. Barter was common. Coal, tobacco, and dairy products were acceptable as legal tender and much more in demand. Business thrived and the English abounded.

By the mid-1880s, the English inhabitants of East Liverpool made up 75 percent of the town's population. It is little wonder that James Bennett, the emigrant English potter of several chapters earlier, found welcome and financial success as a potter in this area in 1840.

The English potters in this Ohio area managed to maintain most of their English traditions, even after the Industrial Revolution overtook many other trades with its machine production techniques, its social upheaval, and its exploitation of the masses. The English family remained the core of the East Liverpool potting industry, and English customs and English methods continued there without interruption. The master potter, not the pottery owner, assigned the individual duties to his staff and chose the appropriate intermission for the English breakfast each morning, as well as the afternoon spot of tea and biscuits.

Fathers worked as molders, kilnmen, or jiggermen for as little as $8 a week, or as much as $20 if highly skilled. Wives and daughters decorated and painted the crockery; while strapping sons loaded the kilns, toted the saggers, or walked the fifteen miles each ten to twelve hour shift as mold runners, carrying an estimated four thousand pounds of clay every workday. Conditions within the pottery were dusty. Work was always strenuous. Potter's asthma frequently shortened the lives of many men and brought tragedy to those families engaged in the trade. Households pooled their resources, socialized in English-type pubs, and maintained their Anglican faith.

After the Civil War, when life resumed a more normal pattern and manpower again became available, East Liverpool and its environs grew until the area boasted of nearly ninety potteries. By 1880, East Liverpool and Wellsville were known as

the ''Crockery Cities.'' Here was produced some of the country's finest Rockingham-type wares, redware, yellowware, whiteware, and majolica. The Museum of Ceramics in East Liverpool, a division of the Ohio Historical Society, houses an extensive and impressive collection of the antique crockery, majolica, and choice china made in the area during the earliest period of 1807-1900 to the present.

In 1852 George Morley, a skilled English potter, settled in East Liverpool. He first worked for Woodward, Blakely and Company, but then in 1870 he formed a three-way partnership with James Godwin and William Flentke. Together, they operated the Salamander Pottery Works. After eight years, Morley withdrew from the firm and moved to Wellsville. Here he established the Pioneer Pottery Company at the southwest corner of Commerce and Ninth Streets, and fired his six-kiln plant successfully.

Morley potted his first majolica in 1879, coinciding almost perfectly with the establishment of the Etruscan Pottery Company of Griffen, Smith, and Hill in Phoenixville, Pennsylvania. In marking his majolica, Morley stamped some of it with ''Morley & CO.'' above the word ''Majolica,'' which he sometimes spelled with a single ''l,'' sometimes with ''ll''. Below the word ''Majolica,'' he placed ''Wellsville, O.'' Later, after returning to East Liverpool, he stamped his majolica in capital letters with ''GEORGE MORLEY'S MAJOLICA. EAST LIVERPOOL, O.''

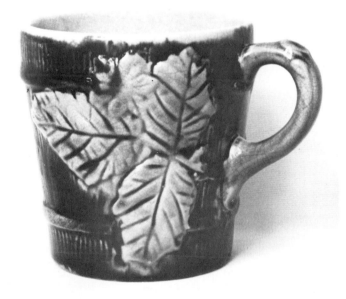

*A rustic, ribbed mug in cobalt blue with a green glazing between the ribs to give it a striped effect. The leaf and twig handle was done in a light green, while the interior of the mug was pink-washed. Signed Morley.*

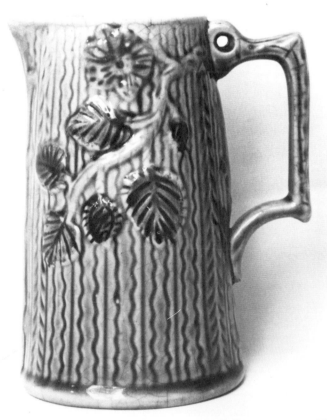

*A Morley-signed rustic jug made both with and without a pewter top. The body received an overall green glaze, while the sprig of leaves was decorated in brown tones and the small flower in soft yellow. The jug's interior was given a gray-blue wash.*

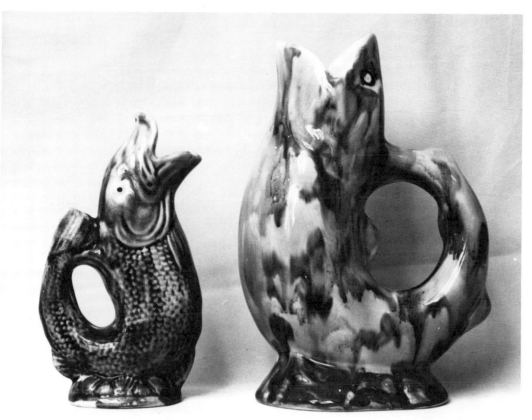

Among his first introductions was a beautifully designed tea set with a raised basket weave body decorated in soft yellows over which lay a fresh green and pink branch of bamboo leaves. While far from original in design, and most likely an English counterpart, it was new to his customers.

Another Morley creation was a shell-footed fruit or salad bowl in the shape of a large conch shell decorated on the outside in earthy browns, executed in high relief. Some of these bowls received a traditional pink interior wash, while others were done in a sea blue color. Either way, Morley's shell bowl was a major piece of American majolica, expertly fashioned, and much coveted today by collectors.

Raised-relief fish pitchers in several sizes, often called "Gurgle Jugs" because of the gurgling sound they produce when pouring, were also Morley offerings. In his catalog, he called one of these pitchers a "Bouquet Holder." Seemingly, Morley either enjoyed fish or found their design very marketable, for he also devised a large wall plaque with a pair of good-looking trout strung together in high relief as its focal attraction. For background he chose a pebbly, sandy surface for contrast. Tavern keepers, owners of fish houses, and anglers should have been happy with this piece of majolica.

Covered and uncovered pitchers in a range of sizes and capacities were produced in large quantities. Usually they were designed with a rustic, tree-bark exterior, brightened by a leafy branch in high relief with a blossom or two of wild roses. The covered pitchers, or syrups, were topped off with a fine pewter lid with a thumb lift. Unlike the Phoenixville Etruscan syrups, the Morley syrups were designed with the thumb lift and hinge built into the handle. This same rustic design was also

frequently employed in his potting of octagonal spittoons. Other cuspidors received a pebbled exterior surface with a rope-twist trim around the top.

Probably the best-known pitchers, and most sought after today, are his figural ones. These were molded into statuesque forms of owls and parrots with special attention given to the feathers and faces of the subjects. Indeed, they are most colorful, with much high-relief work that affords them excellent depth and dimension, and proves especially satisfying to the naturalist. Such pitchers command top prices today and are difficult to find, especially if marked with the Morley stamp.

On an interest level with the figural pitchers are Morley's "Napkin Plates" — those Victorian novelties which simulated a folded, usually broad-fringed, napkin placed neatly across a luncheon or dinner plate (as was the Victorian custom). Most of these plates are vividly handsome and a delight to the collector. If Morley copied the English version of this design, he did so with great deftness of design and decoration.

We do know that George Morley had a son who also became a potter. Whether his Christian name was John, or whether George had a brother named John, has

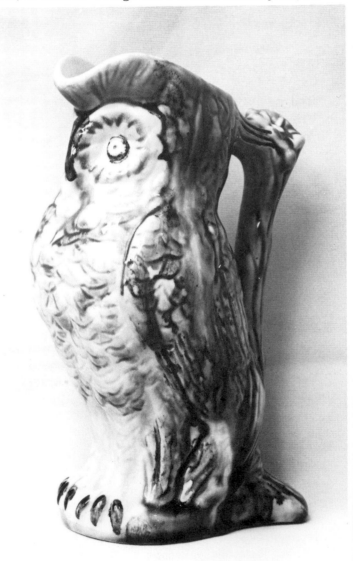

*Another figural offering. This one is a Morley-signed owl with a rustic handle and flower thumb grip. The bird is gray breasted and speckled with brown. The wings and back were decorated in dark green and brown. The yellow eyes were rimmed with jet black, as were the long talons.*

never been clearly delineated. We do know that a John Morley crossed the Ohio River into West Virginia and opened a pottery in Chester, where majolica was also made.

In later years George Morley and his son formed a partnership upon their return to East Liverpool from Wellsville. Together they purchased the Lincoln Pottery from Messrs. West and Hardwick. At times, it is reported, the partnership employed the same molds for the manufacture of majolica and ironstone, alike. So, it is entirely possible to find a unique twosome in Morley-made wares. As to the stamping of their wares, on occasion they used "E.L.P. CO." to mark their East Liverpool Pottery wares, but such marked pieces are rare among collections today.

With the large number of potters concentrated in the East Liverpool-Wellsville area, it seems more than likely that more majolica was made in the region than just that potted by the Morleys. But since none of them chose to identify themselves or their wares, little can be reported factually. It is known that the Buckeye Leaf pattern was a popular Ohio offering, as well as the corn motif so closely associated with the grain belt of America. Both patterns are truly American and popular with the collector today.

As for the latter years of George Morley, he retired from his trade in 1890 after thirty-eight years of master potting, but not to rock away his golden years. Instead, he ran for the office of mayor of East Liverpool, and won. In that capacity he served his town until 1896, leaving behind an enviable record of accomplishments.

Today, collectors continue to search for the Morley-marked majolica, as well as the Buckeye Leaf and Corn patterns native to the Ohio potters who left us all richer in heritage because of their legacy in clay.

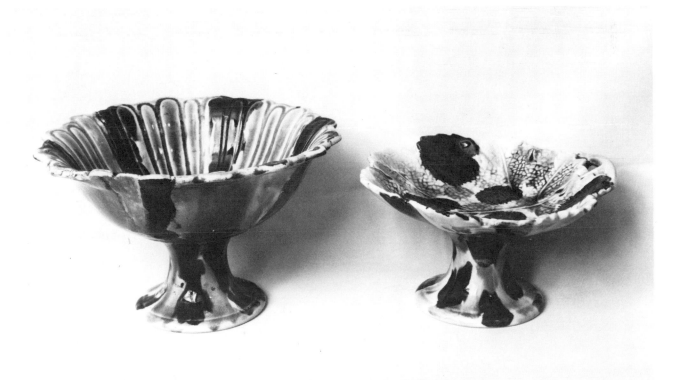

*Two pedestal bowls by Morley and Company of Wellsville, Ohio. The one on the left was advertised as a "Fruit Dish" and the other as a "Leaf Comport." Both received the Morley decoration — a mottling of brown and green glazes, inside and out.*

An unmarked piece of American majolica attributed to Morley as one of his series of "Shell Salad Bowls." With its low pedestal, this one might have served as a centerpiece as well. The exterior of the conch shell was decorated with a bright lemon glaze, while the interior was done in a pale pink wash. The bamboo leaves on the base were painted a tropical green.

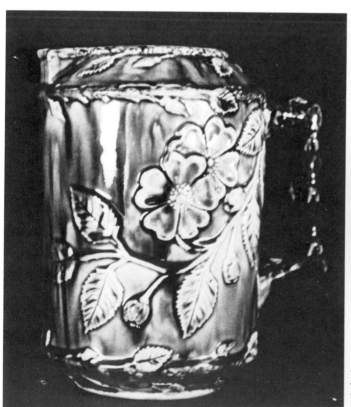

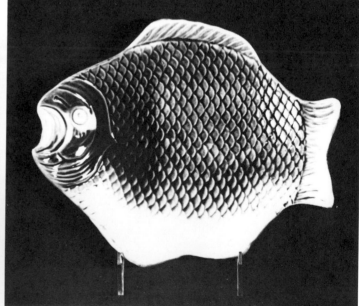

An intriguing fish tray, unsigned, but well-defined in every respect. Possibly an Ohio piece.

Another unsigned American jug, but well done in the popular rustic styling. The bark-textured body was decorated in dark, mossy green, while the overlay of leaves and flowers was bright green and dogwood pink.

# 7 Majolica Giant

After twelve years of reorganization, managerial changes, and recurring tight money situations, the original Phoenixville Pottery, Kaolin and Firebrick Company of Pennsylvania, resolved into the pottery firm of Griffen, Smith, and Hill. On January 1, 1879, the partnership of Henry R. Griffen, his brother, George S. Griffen, David Smith, and William Hill began operations with $60,000 in capital, high hopes, and soon-to-be-discovered latent potential.

The company began to produce what was in demand in early 1879, namely, yellow and white pottery, parian, terra-cotta, and Bennington-type crockery. Early in their first year of operation, David Smith, one of the partners and probably the most skilled potter of the four, began experimenting with glazes and earthenware bodies. Exactly when Smith created his first piece of majolica is unknown, but by April of 1879, the idea of entering the majolica market proved so agreeable to the owners that plans were made to produce the ware in volume.

To introduce their first line of majolica, the partners decided to impress this earthenware with their initials — GSH. From that day forward, majolica history was written in Phoenixville, Pennsylvania. However, before the first batch of majolica was ready for sale, William Hill, one of the four partners in the firm, withdrew from the organization. The 1880 census record revealed the name change when it carried the firm's new title as Griffen, Smith and Company — Stoneware and Earthenware. The new triumvirate, the two Griffen men and David Smith, decided to keep their monogram — GSH — intact, which the firm amusingly referred to thereafter as standing for ''good, sturdy and handsome.''

During the full decade of the 1880s, the impressed monogram was used frequently to mark their majolica. When the gentlemen selected the name ''Etruscan Majolica'' to encircle their monogram is conjecture. On occasion, the company also impressed the words ''Etruscan Majolica'' in a straight line to mark some of their output, or combined it with the monogram as well. To say the least, Etruscan majolica can be easily sorted out by the beginning collector or the dealer.

In addition to these varieties of markings, some of their majolica was incised with a capital letter and one or two Arabic numbers. Such markings were employed to identify particular pieces of pottery. For instance, C-12 can be found on the underside of their ''Oak Bread Tray'''; E-10 refers to their ''Bamboo Teapot.'' A few of the smaller Etruscan pieces, like the Coral salt and pepper shakers, provided no room for their usual monogram, but were acknowledged as Etruscan by the mark, L-15. Even smaller pieces, such as the individual salt dips in the Lily pattern and the equally small Lily vases, may be totally unmarked, as the bottoms of neither provided a flat surface for doing so. Such unmarked pieces are very rare, but again, they can be identified through the lithographed *Catalog of Majolica,* published for the World's Industrial and Cotton Centennial Exposition of 1884.

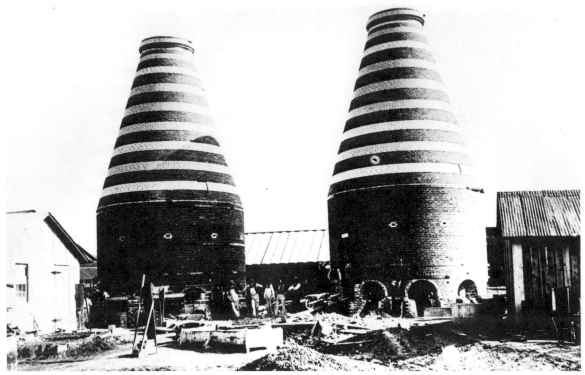

*The giant twin kilns and potting sheds of the Griffen, Smith and Company pottery in Phoenixville, Pennsylvania, in the 1880s. Courtesy of Helen Cornog.*

Griffen, Smith and Company needed a miracle in 1879 if they were to survive their infant years as majolica potters; for southward, the Edwin Bennett Pottery Company and the Chesapeake Pottery Company in Baltimore, Maryland, seemingly had the majolica world wrapped around their fingers. To the north, James Carr had been making and selling majolica successfully for many years. James Taft of New Hampshire and Charles Reynolds of New Milford, Connecticut, were also established majolica potters. To the west, George Morley was rapidly emerging as a major majolica potter.

Perhaps it all happened as John Steinbeck once wisely wrote in his short story, "Flight": "A boy becomes a man when a man is needed." With all due credit to the Messrs. Griffen, both civil engineering graduates of Rensselaer Polytechnic Institute, it seems most likely that David Smith, an experienced English potter, assumed the challenge of creating most of the fabulous array of majolica that the company was to produce. Whether their master decorator, Thomas S. Callowhill, ever created any of the company's prestigious designs is shrouded in mystery. But create, Smith did. And with every new pattern, Steinbeck's boy grew; and when the man was needed, Etruscan majolica was there — anxious and able.

Out of the Phoenixville kilns came the Cauliflower pattern tea set and matching dinner service — a design of green leaves neatly wrapped around the white, flowering head of the plant. In the case of the plates and saucers, the green leaves unfolded into a white, pebbled, starfish center, not unlike the starfish of the open sea. Then another introduction emerged — the Orientally styled Bamboo pattern — and another tea set and table service. This time the pattern was a brown, earthy design out of which rose the jungle green leaves of bamboo shoots, opening against a yellow-ribbed cane background. Etruscan became one of the first American potters to employ this Oriental motif stemming from the Japanese aesthetic influence already so popular among the English artists and potters.

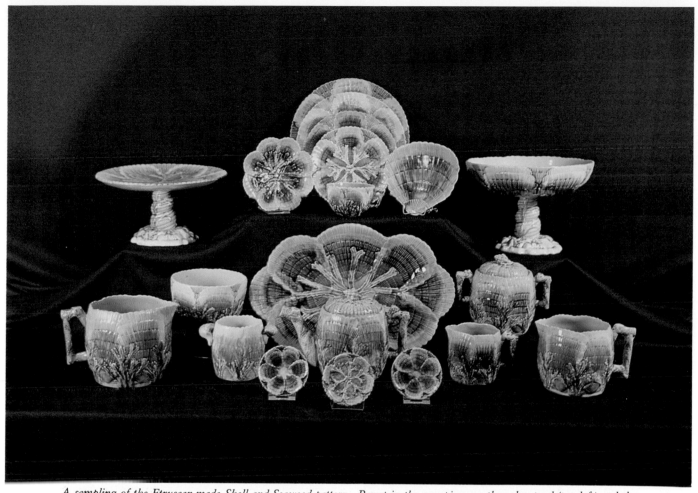

*A sampling of the Etruscan-made Shell and Seaweed pattern. Rarest in the grouping are the cake stand (top left) and the centerpiece (top right). (Top center) An array of plates with a teacup and saucer. To the left of the plate is a sauce or dessert dish; to the right is a shell-footed ice cream dish. (Bottom, left to right) A cider jug; waste bowl; spooner; large serving platter. In front of the platter is a coffeepot, shown here with a crooked spout (but also potted with a straight spout) and three butter pats (two without seaweed). To the right of the platter are the lidded sugar, the creamer and another jug.*

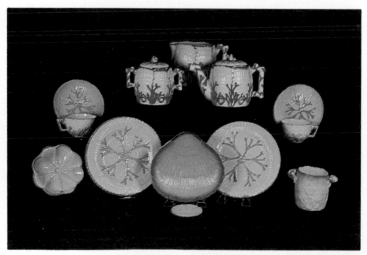
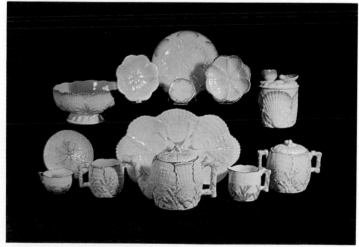

*Representative styles of decoration used in the manufacture of the Etruscan-made Albino Shell and Seaweed. The Albino styling preceded the full-color line. Far less Albino was produced. Rarest within the Albino group are the cigar box with its two-shell lid and the shell-footed, low salad bowl. Much of the early Albino line was never marked.*

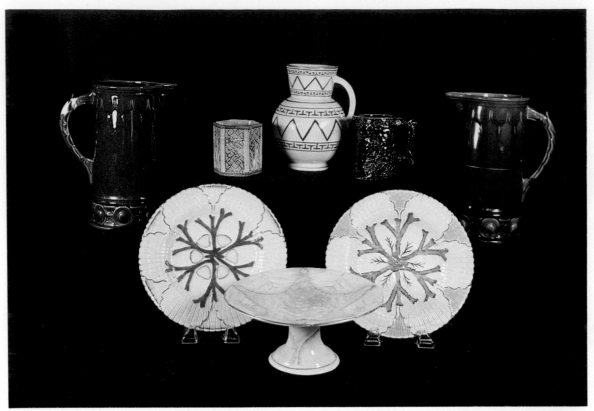

All of the Etruscan majolica shown here is hard-to-find, if not rare. The large cider jugs (top left and top right) are similar to the Ball Players Cider Jug, but even rarer. (Top center) A water pitcher belonging to a bath set which originally included a bowl and a lidded soap box with a Star-of-David finial. To the left of the pitcher is a Bird and Bamboo spooner. To the right is a small Rustic jug, seldom seen with cobalt decoration. (Bottom) Three more Etruscan-made Albino renditions — two Shell and Seaweed dinner plates and a Cauliflower cake stand.

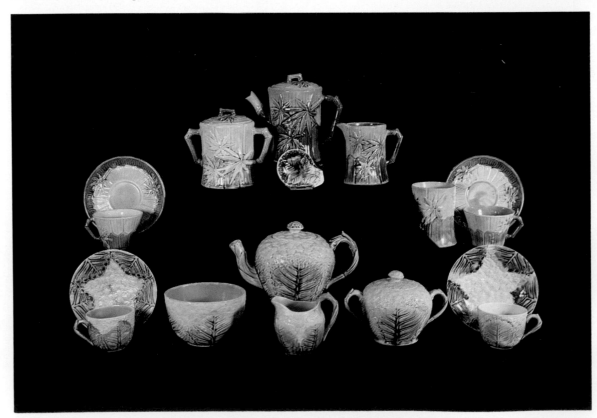

(Top) Etruscan Bamboo luncheon service. (Bottom) Cauliflower tea service made by Griffen, Smith and Company. The service included both 8- and 9"-plates and a cake stand. Interior glazes vary from pink to green in both patterns.

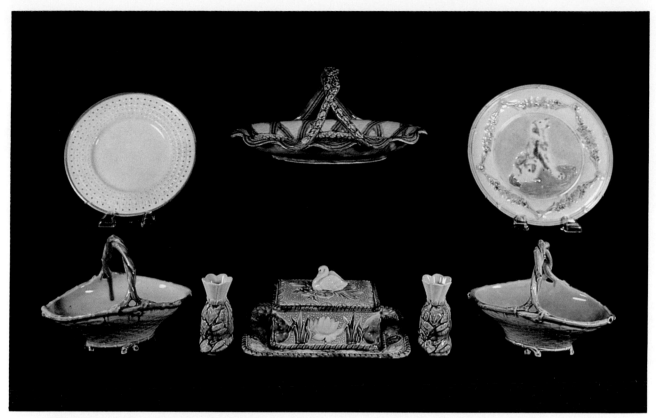

All Etruscan and all rare. (Top center) A Begonia and Wicker basket, G-2. (Top left) A stylized Corn pattern plate in albino. (Top right) A serving plate seldom seen in albino and color. (Bottom, left and right) A pair of Wicker baskets. (Bottom center) The complete N-1 sardine box with undertray. Undertrays were sold separately in the 1880s. Flanking the sardine box are a pair of Lily vases, L-7, each about 3".

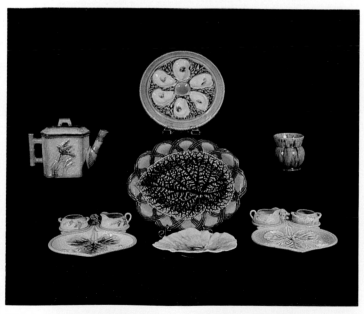

(Top center) Extremely rare Etruscan oyster plate. (Top left) A Bird and Bamboo teapot shown here in white, but also decorated in deep blue. (Top right) Etruscan-made spooner in the rare Ivory pattern. (Middle center) A Begonia and Wicker fruit tray, C-3, which, with a handle added, became a basket, G-2. (Bottom, left and right) Two Etruscan strawberry servers with sugar and creamer inserts. Between them is a Begonia Leaf relish dish.

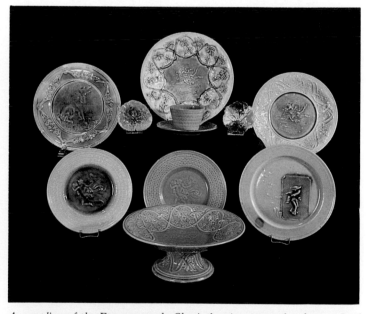

A sampling of the Etruscan-made Classical series, except for the two Leaf pattern butter chips. Most often decorated in the sepia coloring, as seen in the pedestal bowl (bottom) and in the plate behind the bowl. The series usually employed a mythological setting, such as Hermes in flight or several cherubs riding a flying lion. Extremely rare is the plate (bottom right) with the Oriental peasant sowing seeds. (Top left) The potter's dog. The teacup and saucer (top center) is in the stylized Corn pattern.

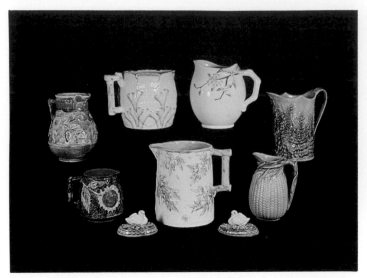

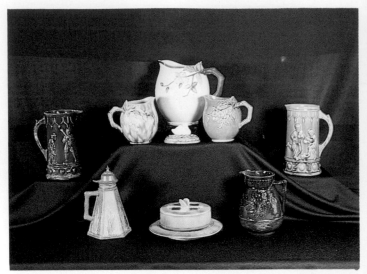

All of the items shown are Etruscan patterns. (Bottom right) The hard-to-find Corn pattern jug, E-5, made in one size only. The albino Hawthorne jug (top center, right) is rare also. Most Etruscan jugs were potted in five or six sizes. Among the rarest of the Etruscan wares are the two swan paperweights seen on either side of the large Rustic pattern cider jug (front and center).

All Etruscan. (Far left and right) Two monochromatic Baseball cider jugs showing both baseball and soccer players. (Top center) A rarely-seen albino Hawthorne jug with above-the-glaze decoration. To the left and right of the jug are two Thorne jugs in a smaller size. The left one is decorated in the traditional styling. (Bottom, left to right) The Orientally inspired Iris and Bamboo Molasses Jug; the Butterfly butter dish; a cobalt, Rose pattern jug, E-3.

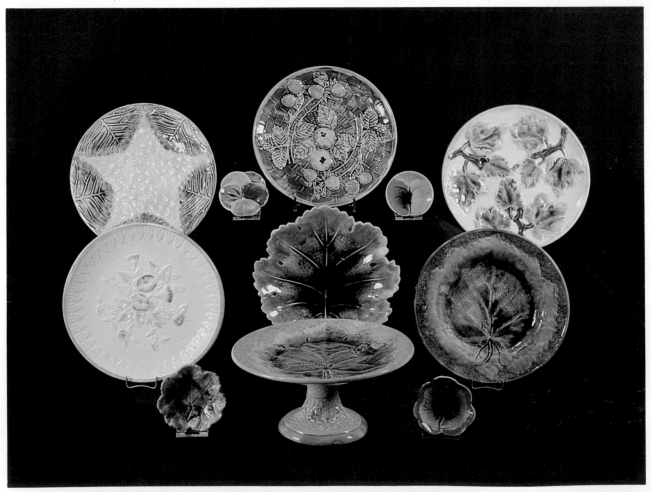

A variety of Etruscan-made plates and serving pieces. (Top, left to right) The Cauliflower pattern; the Strawberry pattern; the Maple Leaf pattern. (Second row, left to right) An albino Morning-Glory plate; a Leaf pattern serving dish; the Leaf-on-Plate pattern. (Bottom center) A Leaf-on-Plate cake stand. The butter pats (top center, left and right) are the Pansy and Lily Leaf patterns, respectively. (Bottom, left and right) The original Geranium pattern butter chip and a later version of the same pattern.

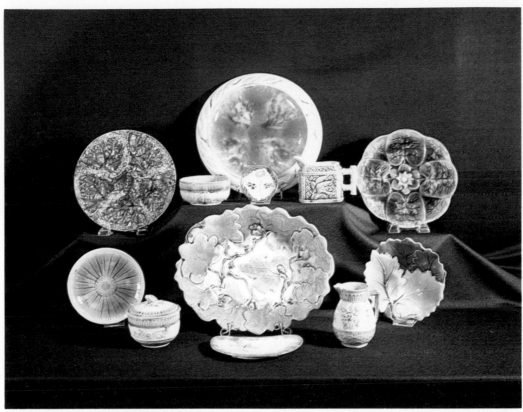

*All Etruscan, except for the Morning-Glory butter pat and the bone dish (bottom center). (Top, left to right) The Begonia plate; the low Lily bowl; the rare, Wheat pattern bread tray; the Bird and Bamboo creamer; the Pond Lily plate. (Bottom, left to right) A Conventional, sometimes called Cosmos, dessert dish; the Wild Rose sugar bowl, seldom signed; the large Oak fruit tray; the Wild Rose creamer; a Leaf pattern dessert dish, B-3.*

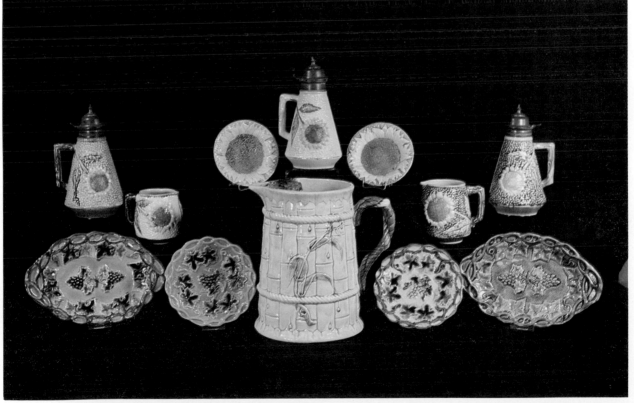

*(Top) Samples of the Etruscan Sunflower pattern. Two traditional molasses jugs and a rare albino jug, flanked by two Sunflower underplates. (Bottom) Two Grape pattern fruit trays and matching fruit dishes. (Bottom center) A large, cider jug, originally owned by a woman whose mother was a decorator at the Phoenixville Pottery. Six such jugs were potted by the Etruscan firm. One was a gift for President Theodore Roosevelt; the other five were given to company employees.*

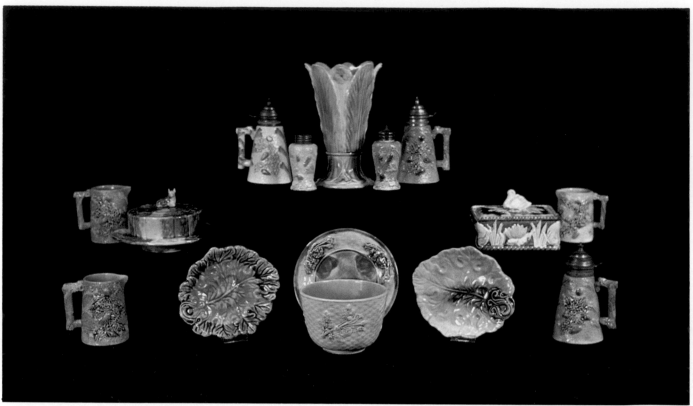

*(Top center) The Etruscan celery vase, L-6. Surrounding the vase are examples of the rare, Etruscan Coral pattern; two syrups and a pair of salt and pepper shakers. (Second row, left to right) One of the Coral pitchers potted in three sizes; the Cow butter dish; the Swan sardine box without undertray; another Coral pitcher. (Bottom, left to right) The largest of the Coral pitchers; a signed Tenuous Leaf plate; the Etruscan high Rose bowl and matching underplate; another Tenuous Leaf plate; another Coral syrup.*

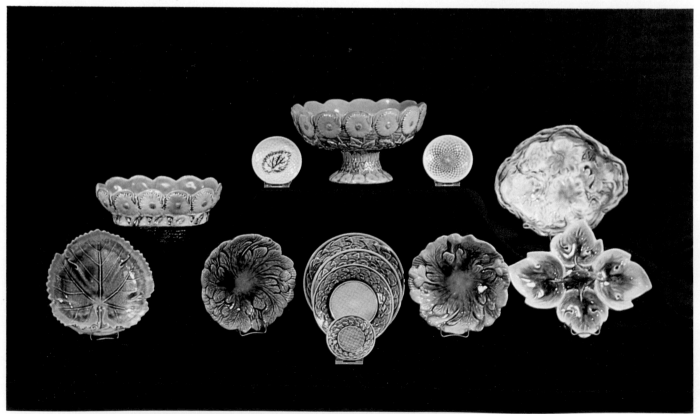

*All Etruscan. (Top, left to right) One of the three sizes of the Daisy saucedishes; a Wicker and Begonia butter chip; the Daisy salad bowl; a Wicker butter chip; the Oak card tray, C-1. (Bottom, left to right) A Leaf tray, B-6; a rare B-4 Leaf dish; three fruit plates in the Smilax pattern, including the individual butter; a traditional B-4 Leaf dish; a very rare spice tray, C-10, with twig handle.*

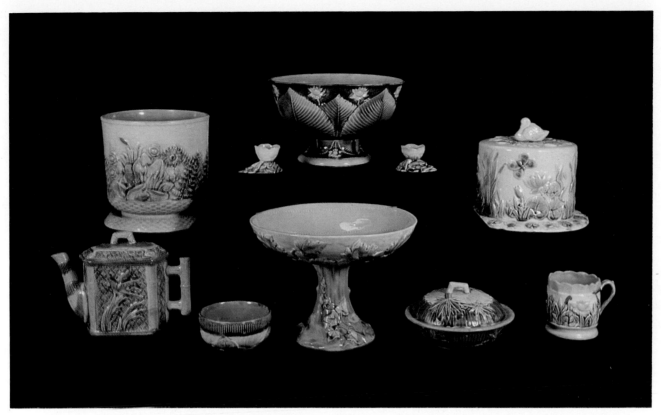

*An array of Etruscan wares. (Top, left to right) The Fern and Wicker two-piece flowerpot; an individual Lily salt dip; the Lily salad bowl; another Lily salt dip; the high-domed Lily cheese keeper, N-5. (Bottom, left to right) A Bird and Bamboo teapot, E-19; the low Lily bow, M-1; the stately Maple centerpiece, J-2; a Bamboo butter dish; a Lily mug, L-5.*

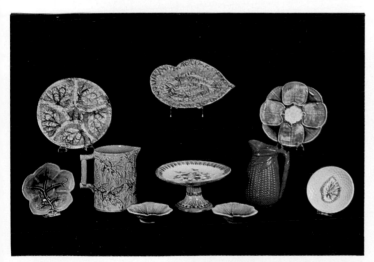

*Etruscan. (Top, left to right) A Begonia Leaf plate; a large Begonia Leaf tray; a Pond Lily plate. (Bottom, left to right) The B-1 Leaf dessert; a Rustic jug; two smaller B-1 Leaf dishes on either side of a Morning-Glory card comport, J-6; a Corn jug in a rare color; a Begonia Leaf-on-Wicker fruit dish.*

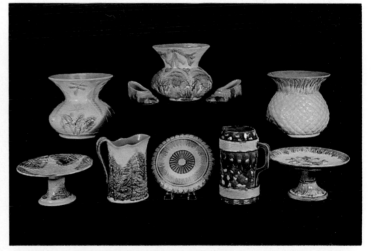

*Etruscan majolica. (Top, left to right) The Lily cuspidor; the Shell and Seaweed cuspidor flanked by a pair of lady's slippers, most likely made as a gift by one of the potters; the Pineapple cuspidor. (Bottom, left to right) A traditional Cauliflower cake stand; a Fern jug; the rarely seen Conventional tea stand; an equally rare Straight jug, potted in only three sizes; the traditionally decorated Morning-Glory card comport, also made in albino.*

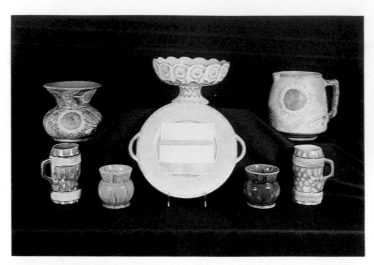

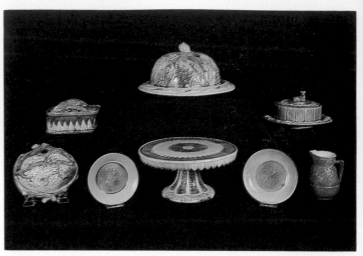

Etruscan. (Top, left to right) The Sunflower cuspidor; an albino Daisy salad bowl; a Sunflower cider jug. (Bottom, left to right) Another Straight jug; two Ivory pattern spooners on either side of the rare Napkin cake tray; another variation of the Straight jug.

(Top, left to right) Another version of an Etruscan sardine box; the Fern cheese keeper, an Etruscan rarity; the Cow butter dish. (Bottom, left to right) A hanging soap holder in the Rustic pattern, very scarce; two individual fruit dishes in the Owl pattern, D-14, flanking the Conventional cake stand, J-4; a unique, bisque-finished Rose jug. All Etruscan.

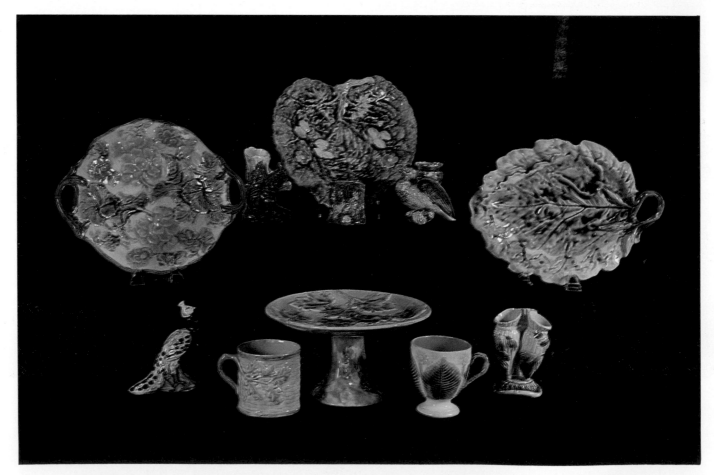

(Top, left to right) The Etruscan Geranium serving tray; a small, Squirrel-at-the-Stump vase, unsigned; an unsigned Strawberry server and an unsigned Rustic toothpick holder, scarce; a Bluebird vase, unsigned; an Etruscan Oak bread tray. (Bottom, left to right) A rare but unsigned Peacock bank; an Etruscan Oak mug, L-13; the Etruscan Maple comport; the seldom-signed Etruscan Lily mug, O-3; an unsigned, triple-throated vase in the Bamboo pattern.

Along with these two patterns, the Phoenixville Pottery developed an albino Shell and Seaweed pattern which proved unique; but it lacked popularity, largely because of its monochromatic, off-white shell body, sometimes edged with gold or combined with a feathering of pink and turquoise blues. It was not until the decorators dropped the albino treatment and painted lush pink and gray seashells with an interspersing of sunlit seaweed that the pattern made its biggest splash. Now the pattern brought to mind the pounding surf of the sea, the image of that watery world bright with coral grottoes, swaying sea fans, and fabled mysteries. Steinbeck's boy indeed flexed his muscles over this pattern; for within two years, this little-known company that emerged from nowhere was bidding to crowd out all of its competitors. Griffen, Smith and Company became the major business that put Phoenixville, Pennsylvania, on everybody's map. That Steinbeck boy did become the Etruscan giant that ruled a potting empire.

These three patterns, alone, would have been enough creativity for most potters, but not for Griffen and Smith. They were already preparing for the New Orleans World's Industrial and Cotton Centennial Exposition of 1884. In doing so, they created nearly two hundred individual pieces of majolica which would range in wholesale price from a halfpenny apiece for butter pats to a top price of $1.30 each for covered cheese keepers.

In the selection of designs for Etruscan wares, no pattern became more associated with the firm than the begonia leaf. This earliest pattern choice for serving trays was taken from the *Begoniaceae,* an exotic, West Indian tropical tuber grown in many homes for its ornamental foliage which is deeply crinkled, ovoid in shape, and intensely multicolored. To come as near to nature as possible in the modeling of this pattern, actual begonia leaves were pressed into soft clay, and their impressions were then transferred to plaster molds for firing. The decorators were given leaf samples to paint by, and, since no two leaves are ever exactly alike, the artists' renditions ran the gamut of jungle hues. Probably no other Etruscan pattern was so imitated, so copied, as this one. And by the sheer numbers of the leaf trays produced, the pattern became almost a symbol of Etruscan majolica.

For other leaf patterns, young girls were sent out to search the lanes and roadside banks, especially along Blackrock Road near the village of Oaks. Others searched the meadowlands and woodlands for suitable subjects that might become attractive patterns. What the young girls returned with were sprays of wild roses and butter-cups, fresh oak and maple leaves, pond lilies and sunflowers, ivy tendrils and fern fronds. Each of these subjects was pressed into use and deftly modeled into Etruscan patterns.

When we consider today how drab and sordid life must have been during the Industrial Revolution, how dreary and harsh the working and living conditions must have been for the lower and middle classes, it is not surprising that the simple patterns the Etruscan potters employed became a breath of fresh air or a moment of beauty on the kitchen shelf or during a family dinner. The little begonia leaf must have brightened many family meals. Even if a housewife couldn't afford a real begonia plant of her own, the prospects are that she could afford an Etruscan begonia leaf tray for $.15 and cherish it for a long time.

Another trademark of the Etruscan potters was the treatment given their hollowwares, such as bowls and pitchers. Nearly always, such pieces were washed inside with pink glazes which often varied in depth of color depending on whether

the paints were freshly mixed and stirred or watered down to pale lavender hues. Occasionally, the interiors were treated with a mint green wash; infrequently, they received a pale blue glaze.

The human figure was a rare pattern for the Etruscan potters, and one they reserved primarily for their version of the baseball and soccer players which appeared on their cider jug. As critics are quick to point out, the jug was a direct copy of the Wedgwood one of the 1860s. One alteration by the Etruscan potters made it an American triumph. The English cricket players were replaced by two baseball players, and the switch became an Etruscan winner. For Etruscan collectors, let it be pointed out that the ball players jug was produced unmarked at times, and it sometimes will be found in an overall cobalt glaze or a forest green, which immediately sets it aside from the most popular polychrome version. Both stylings, however, are Etruscan. Its piece number was E-6.

To top off their venture into the big time, Griffen, Smith and Company were awarded the Gold Medal, the highest possible honor, for two vases and a jug which they entered in the 1884 exposition competition. Following the exposition, the company was flooded with orders from all over America, and the firm was forced into day and night operations to fill the mounting orders. The number of full-time employees was tripled, and many steam-powered, labor-saving machines were added to speed production along. Their exposition catalog, in fully lithographed color, was in great demand; for from it, the jobbers could order by number and know exactly what they were buying.

Lady Luck never reneged in her affection toward the Messrs. Griffens and Smith, for the day soon arrived when the Great Atlantic and Pacific Tea Company placed a mammoth order with the firm for majolica to be given away in their nationwide coupon sales promotion. This last straw might have broken the camel's back, but not the back of Griffen, Smith and Company. They met the challenge and grew.

Elsewhere, the dark finger of Fate was beginning to admonish America's majolica makers with warnings of overproduction, cheaper and more cheaply made wares, and trite introductions of the penny-souvenir variety. It appears no one listened, or if they did, it was with the unbusinesslike notion that majolica would go on forever.

Importers along the East Coast, too, were receiving regular shipments of majolica from as far away as the Sarreguemines Pottery in France and Villeroy and Boch in Baden, Germany. Even Poland was treating us to their innovative ''sanded'' majolica with its extruded, full-blown roses and extended leaves. England, especially, never gave up the struggle for a lion's share of the majolica market.

As for the Etruscan firm in Phoenixville, Mr. Smith withdrew his association with the company in 1889 because of failing health, and J. Stuart Love, father-in-law of Henry Griffen, succeeded him in the organization. The firm's title then became known as Griffen, Love and Company, and the company's capital was increased to $125,000. The employee roster topped one-hundred fifty men, women, and youngsters, a far cry from the initial fifty-five men, nineteen girls over fifteen years of age, and twenty-three children in the 1880 census.

Catastrophe hit the Phoenixville pottery on December 3, 1890, when a disastrous fire destroyed most of the facilities and forced the firm's temporary closing. Before the structure could be rebuilt and reopened in April of 1891, the

craze for majolica had, also, all but burned itself out. What survived of the original Griffen, Smith, and Hill Pottery Company resolved into several reorganized companies that engaged themselves in the manufacture of semigranite wares, flow blue pottery, and decorated and undecorated ironstone. In 1903, the plant was permanently closed.

Except for Edwin Bennett and D.F. Haynes of Baltimore, the competition for leadership had nearly vanished. The craze for majolica died as quickly and as quietly as it had been born. By 1900, its race had been run. Today, the corner of Starr and Church streets in Phoenixville, Pennsylvania, bears no reminder of that time when those two great, beehive-shaped kilns belched smoke up and down the Schuylkill Valley. Gone is the distant rumble of wagons that carted away crates full of good, strong, and handsome Etruscan majolica. Yet, in the hearts of majolica collectors today, there lives the memory of a time and a pottery that will always be remembered as the ''Majolica Giant.''

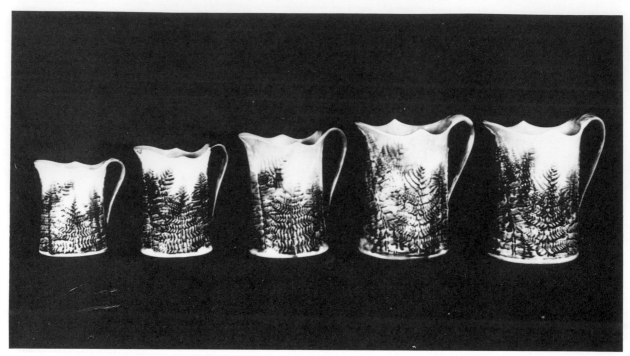

*An array of the Etruscan Fern pattern in jugs. The green fern fronds were modeled in high relief over an off-white body. The pink interior wash was repeated on the tips of the fronds. Number E-7.*

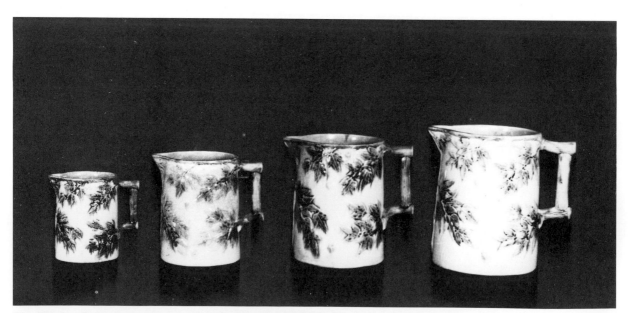

*The Etruscan Rustic pattern reserved largely for jugs and mugs. Pictured are four of the five sizes the company potted using number E-2. Extruded green leaves were laid across a tan-to-brown body.*

44

The Shell and Seaweed cigar box, a plum among collectors. This
model was produced in albino, as well as in the traditional pink
and gray colors. Note the inversion of the green seaweed reserved
for this piece of Shell and Seaweed alone. Number M-10.

A signed cup and saucer in the stylized Corn pattern potted by the Etruscan makers. The cup and
saucer and matching plates were given an overall, soft sepia glaze with an antique gold trim.

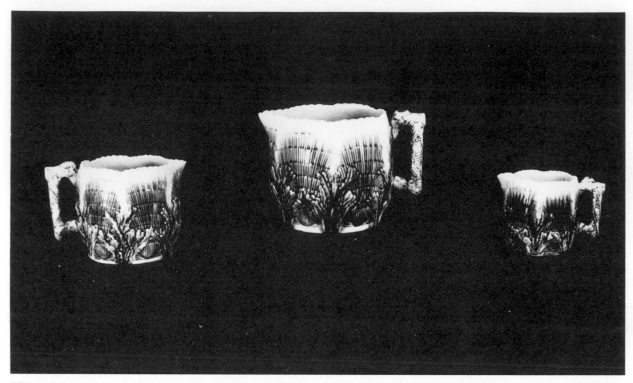

*Three of the seven sizes of Shell and Seaweed jugs. To the far right is the smallest of the series and a selection from the tea set. The number for the series is E-26.*

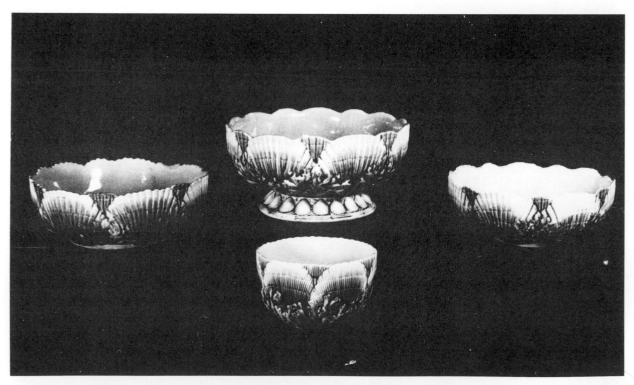

*A selection of the Shell and Seaweed bowls. (Left and right) The two sizes of nappies, number M-5. (Top center) The salad bowl, number J-8. (Bottom center) The small waste bowl belonging to the tea and coffee set, number M-12.*

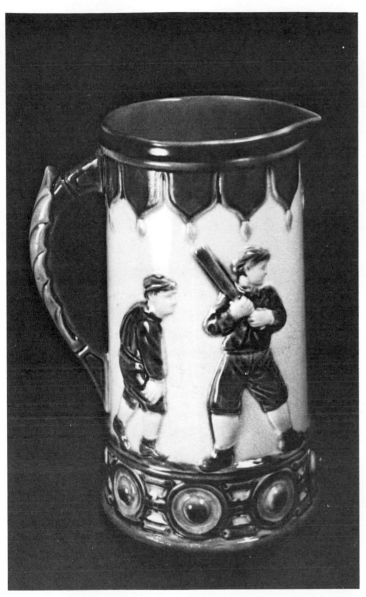

The E-6 "Ball Players Jug" showing the baseball boys. Soccer players appear on the reverse side. A similar jug, but much rarer, was also potted without either pair of ball players and decorated in overall, monochromatic greens or blues. Rare in either styling.

The Orientally inspired "Bamboo and Iris Molasses Jug," number E-22. Original pewter top.

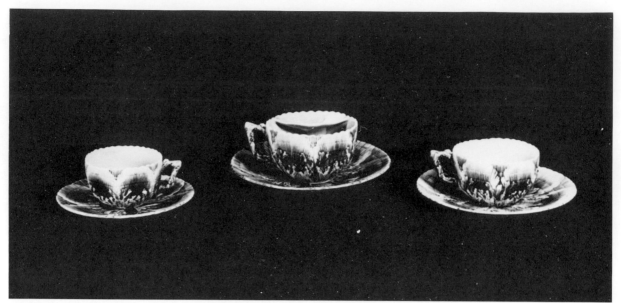

The three styles in Shell and Seaweed cups and saucers. (Left to right) The teacup; the gentleman's moustache set with the original 7", coupe-shaped saucer; the coffee cup, also with its original 7" saucer. Cups were never signed; although saucers generally were. Numbers: teacup, O-4; coffee, O-5; moustache, O-6. All are found in albino decoration as well.

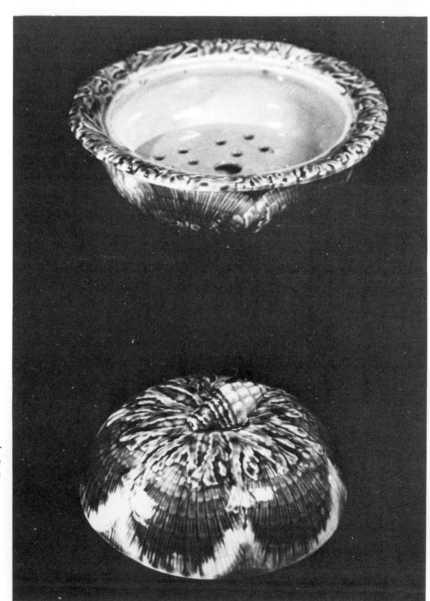

The Shell and Seaweed covered butter, number N-7, showing the original pink liner with the perforation which allowed the butter to chill above a bed of chipped ice. Extremely rare.

# 8 The Baltimore Perfectionist

Two names become intertwined in the unfolding of the Baltimore story of majolica. The first is that of Edwin Bennett whose service and contributions to the evolution of majolica in America have already been presented in an earlier chapter. The other is that of David Francis Haynes.

Born of Puritan stock in 1835, David Haynes grew up in Brookfield, Massachusetts. In his late teens he found employment as a clerk in a crockery store in Lowell. Young Haynes earned both the confidence and the respect of his employer who increasingly entrusted him with important duties and decision making. By the time Haynes had reached manhood, he was sent to England and the Continent as a representative of his employer.

This experience was both a revelation and an education to the young Haynes who had already expressed a broad interest in the industrial arts. Such exposure to the art treasures abroad was to prove invaluable later to him as a major American potter.

In 1856, after Haynes returned to America, he accepted a managerial position with the Abbott Rolling Mills, manufacturers of plate iron, and moved to Baltimore. When the Civil War erupted in 1861, Haynes was twenty-six years old. In spite of his youth, he was placed in charge of the production of armor plate used by the navy on its famous and much-feared ironclads. Such a responsibility for the young Yankee was both a challenge and a success as he patriotically served his country and his employer during the conflagration.

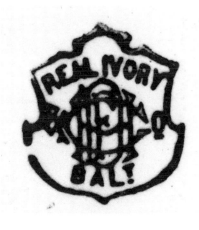

After the war, Haynes was transferred to Virginia where he managed an Abbott subsidiary which mined iron ores and industrial clays. In 1871 he was offered an interest in a jobbing house in Baltimore that supplied crockery to merchants throughout the Bay area. He accepted, and in doing so, Haynes returned to the business that had been so fascinating to him in his youth.

Little more is known of his progress in the pottery business until about 1880 when Henry and Isaac Brougham and John Turnstall, proprietors of the Chesapeake Pottery, were forced to sell out. Haynes appeared on the scene and purchased the pottery on the corner of Nicholson and Decatur streets in Locust Point, Baltimore.

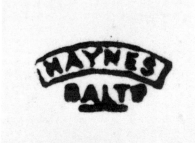

Although majolica making was already a recognized and thriving business by this time, Haynes was determined to enter the competition. Following his own natural and creative instincts, and recalling the works of art he had seen and studied in Europe, he designed and master-potted a complete dinner service in majolica which he introduced as Clifton Decor, fully stamping it as such, along with his personalized DFH monogram. Clifton Decor proved to be a winner. The universal

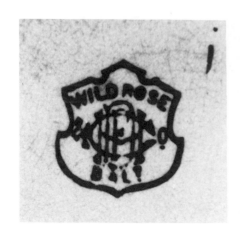

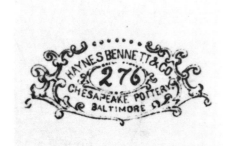

appeal of the common blackberry, which became his first pattern, was a work of art in the hands of David Haynes. While the pattern was a borrowed one from the Wedgwood and George Jones potteries, Haynes chose a more rustic treatment for his. Using a creamy white, rough-bark base, he molded branches of ripe and blossoming blackberries in high relief around the contours of his plates and serving pieces. All of the decorations were painted under the glaze, which he made certain was hard and lustrous.

Haynes followed his first success with another dinner service using the strawberry design. Public acceptance of it was as rewarding as it was to his original. To add greater importance to his first majolica wares, Haynes created punch bowls, mugs, a variety of pitchers, and many attractive vases. Unlike nearly all of his fellow potters, Haynes faithfully stamped his wares, a blessing to collectors today.

For any artist, following such triumphs with equal success would be a challenge, and Haynes was no exception. After much study and experimentation, and again recalling his travels among the museums of Europe, Haynes turned to the earlier French styling and old-world charm in creating a new line of majolica which he called Avalon Faience. In preparing his Avalon majolica, he began with the already popular blackberry and strawberry patterns. But, to set Avalon Faience apart from Clifton Decor, Haynes turned to a less rustic surface and a mellow base tint of desert sand for a beginning. Over this, he added the leafy branches of the berries and the ivy tendrils which this time were painted over the glaze and then refired. The effect was truly antique, soft and mellow, almost impressionistic; the artist only suggested the leaves and berries, and further heightened their design with outlines of antique gold. This was a major departure from most other American majolica. Haynes elevated the artistic quality of American majolica, turning everyday dinnerware into unique creations for the housewife. In keeping with his established tradition, all Avalon patterns were fully stamped with the Avalon Faience seal around his monogram, DFH. This monogram was continued for many years, well into the semiporcelain wares he later produced in abundance.

As acceptance of the Avalon line of majolica continued, Haynes began to add more and more patterns which he employed in the manufacture of planters, jardinieres, clock cases, living-room lamps, and an endless variety of elegant vases. A few patterns were reserved for complete toilet sets that often included as many as ten articles. In rounding out his faience treatment, a Real Ivory faience ware was introduced. All three wares, Clifton Decor, Avalon Faience, and Real Ivory, were produced simultaneously during the 1880s.

David Haynes was enough of an artist himself to realize that the pottery industry was sadly lacking in skilled artists familiar with the modeling and decorating of earthenwares. In looking for a school for his son, Frank, he was unable to find any that offered courses in pottery decoration. Undoubtedly, he was too advanced for his time; besides, the potting trade was too bogged down in the mire of competition to care. Everyone seemed too engrossed in copying everyone else, hiring cheap labor, and keeping down the production costs to worry about founding a school for artisans.

When competent molders could be hired at a top salary of $24 a week, and a kilnman for $15 a week, who needed a school? Employers could find plenty of common laborers who were anxious to work from 7 A.M. until 6 P.M., six days a week, for $1.25 per day. Women and girls could be hired for $5 a week to do the

decorating, but a truly skilled paintress might earn as much as $10 a week. Obviously, the majolica business was not a get-rich-quick venture for either employees or employers.

All pottery owners were forced into competitive pricing of their majolica wares. A wrong guess or a hasty gamble quickly led to financial ruin for many. When majolica plates sold for a penny apiece by the gross, wholesale, pottery owners could hardly hope to become wealthy. Then, too, every American potter had to compete with the foreign-made majolica that kept flooding the marketplace. And, as if all of these factors were not enough, the public consistently considered imported majolica more sophisticated, especially when it came from England.

Through it all, Chesapeake majolica remained in high demand for many years. But, following a major expansion of the pottery, the Chesapeake Pottery Company was forced to sell out at a trustee's sale. It was purchased by none other than the grandfather of the majolica industry, Edwin Bennett of Baltimore, and the company became known as Haynes, Bennett and Company. During the five years of close association that followed, Edwin Bennett and David Haynes went on to win outstanding honors and awards at the Pan-American Exposition in 1891 and again at the Columbian Exposition in Chicago in 1893.

After Edwin Bennett retired from the firm, he sold his interest to his son, Edwin Houston Bennett. He, in turn, for an unspecified reason, later sold his share to Frank R. Haynes, the son of David Francis Haynes. The pottery's name was then changed back to D.F. Haynes and Company, and together, David and Frank Haynes, father and son, continued operations. So successful were they that when the Louisiana Purchase Exposition was held in St. Louis, Missouri, in 1904, the Haynes made pottery again received highest recognition.

*A rare signed Maryland Pottery Company leaf tray. Green veining over white body with gold trim.*

*A typical Avalon-signed majolica clock with original works. Decoration was in varied shades of tomato red, green, and ripening blackberry. Note the Baltimore beetle.*

51

Following the death of David Francis Haynes in 1908, at the age of seventy-three, his son, Frank, continued to operate the pottery alone. Production costs, however, further increased, and Pennsylvania and Ohio potters began turning to low-cost gas for firing their kilns. Besides offering those potters a competitive advantage, gas-fired kilns also produced a finer pottery because of their even-burning performance. This trend spelled doom for many potters who were unable to convert from bituminous coal, and in 1914, after thirty-two years of continuous operation, Frank Haynes was forced to close his pottery. He sold the property to the American Sugar Refining Company, which still occupies the site, today.

*An Avalon-signed jug decorated with polychrome pears and green leaves on an off-white body.*

In its heyday, Chesapeake majolica was never a run-of-the-mill majolica. It was sold in the fashionable John Wanamaker store in Philadelphia, by the elite Marshall Field and Company in Chicago, and, in New York, by the nationally famous Macy's. David Francis Haynes built a national reputation upon the perfection of his wares and a personal commendation as a prominent member of the United States Potters' Association and the American Institute of Mining Engineers. Haynes was also a charter member of the American Ceramic Society when it was founded in 1899. Only the makers of Etruscan majolica ever came close to excelling the Clifton and Avalon majolica made by the Chesapeake Pottery Company of Baltimore. Haynes' majolica was a winner in the 1880s, and it remains highly prized by collectors today.

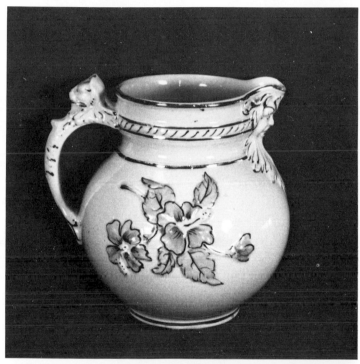

*An Avalon jug with masked spout and griffin handle trimmed in old gold with a leafy branch of flowerlets in shades of beige and salmon. Signed.*

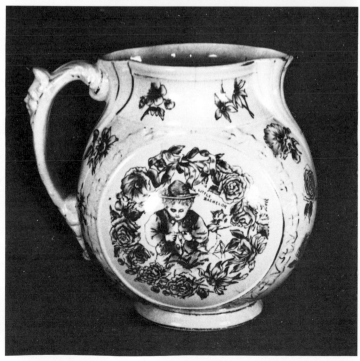

*A Baltimore faience jug with a soft beige body and rose decoration. Note the masked thumb grip on the handle and the small boy with "A Little Bachelor" inscribed within the wreath of roses.*

53

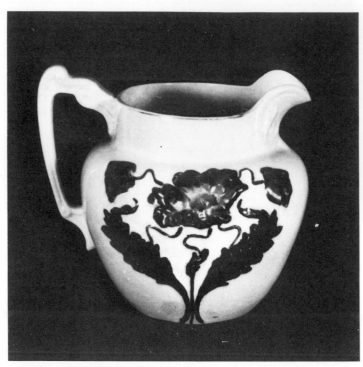

*A Haynes-signed milk jug with raised, Mexican-red poppies on a cream body.*

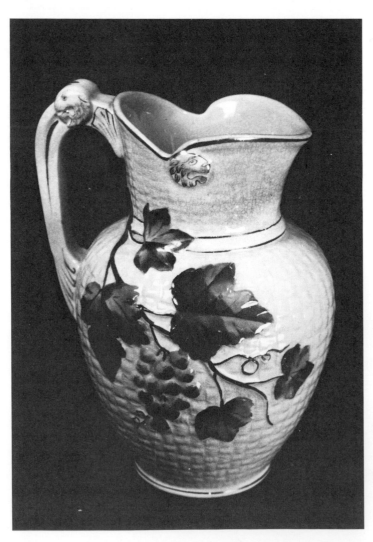

*The grape pattern in an Avalon jug with lion head handle and decoration. Bright fuchsia grape leaves emphasize the off-white wicker body of the pitcher.*

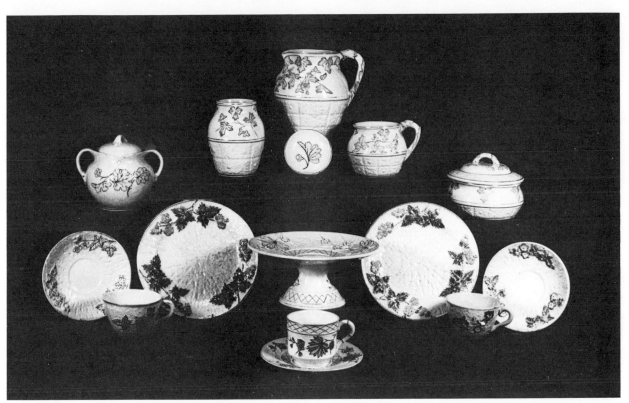

*A collection of several patterns of Avalon ware. All pieces were outlined in antique gold and represent the best of the Haynes line of American majolica. All are signed.*

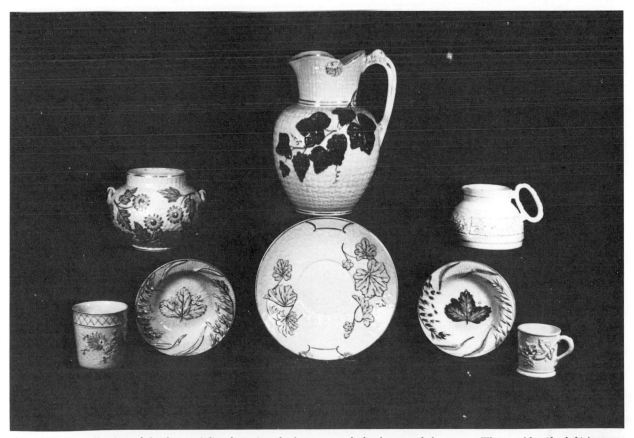

*An exemplary collection of Avalon majolica featuring the buttercup, shaft of oats and the grape. The tumbler (far left) is a rare form in majolica. Equally rare is the small, squat pitcher with the ovoid handle. Each piece in the collection was decorated with an antique beige glaze and signed.*

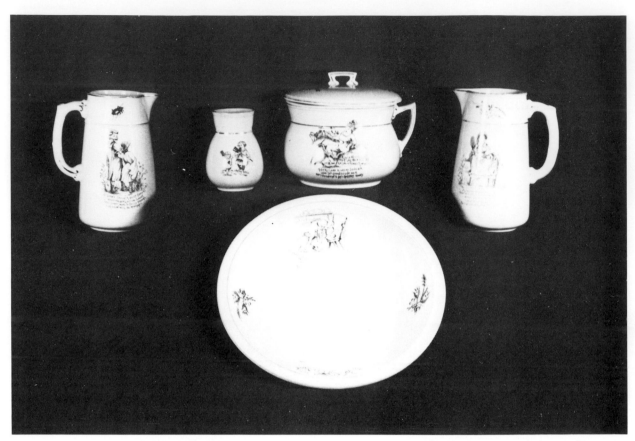

*A selection of Baltimore majolica intended for the young child. Each item has a childhood verse and illustration. One of the pitchers is signed with the "Real Ivory" stamp, the other with "Avalon." To the left of the chamber pot is a seldom-seen toothbrush holder.*

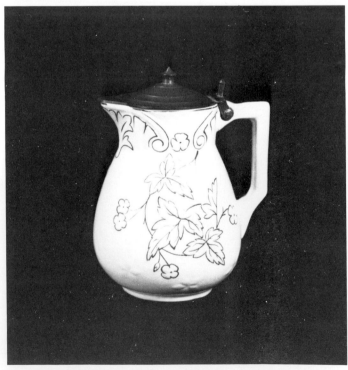

*A pewter-topped, Avalon-signed molasses jug. Note the asymmetry of design and the understatement of decoration.*

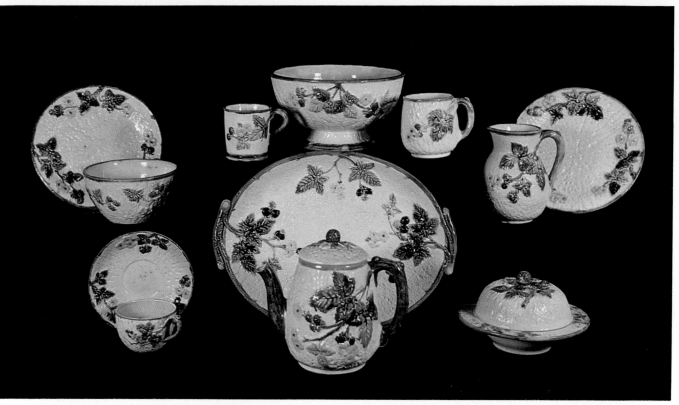

*A sample of signed Clifton Decor majolica made by D.F. Haynes in Baltimore, c. 1879. The Blackberry pattern is the earliest of the many patterns that followed.*

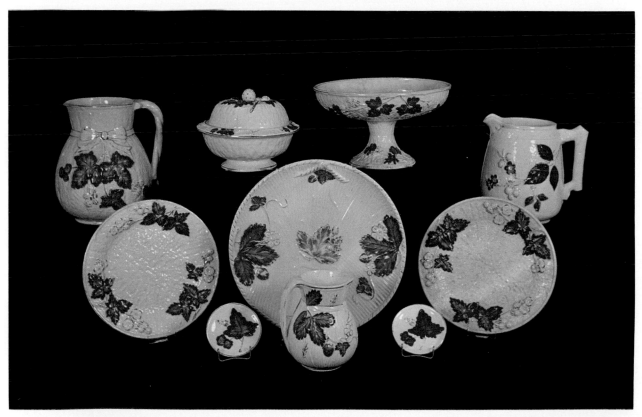

*An array of both the Blackberry and Strawberry patterns made by Haynes in the signed Avalon Faience line. Rarest is the lidded butter keeper and the ribbon-necked jug (top left).*

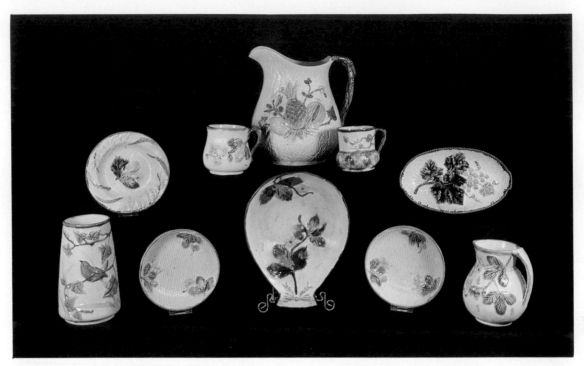

*Clifton Decor majolica shown in a variety of popular patterns. D.F. Haynes offered complete dinner services in the Clifton-marked majolica, as well as children's mush sets and a variety of jugs, mugs, and vases.*

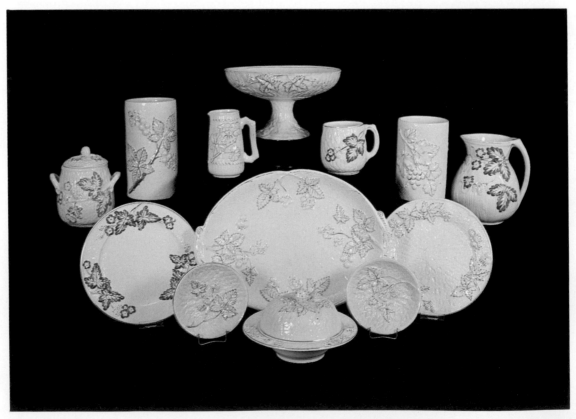

*An Avalon Faience collection in some of the most popular patterns of the 1880s. Haynes preferred understated decoration.*

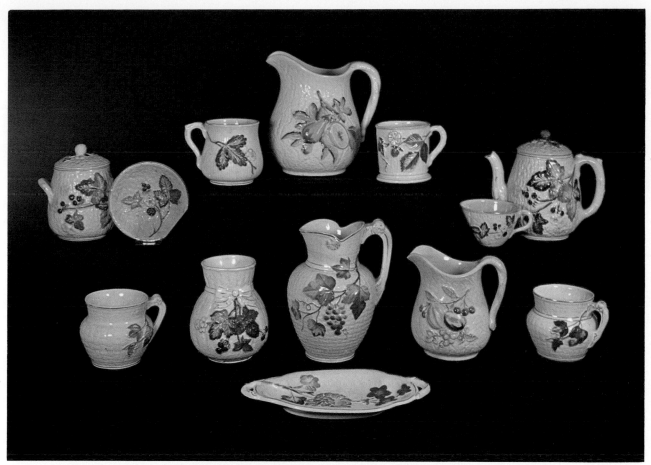

*A variety of fruit patterns in the Avalon Faience majolica.*

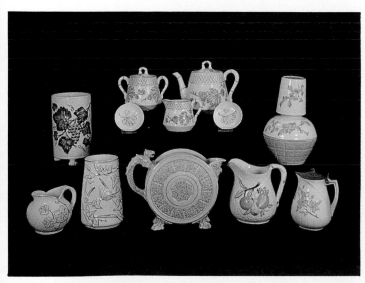

*An Avalon Faience collection including a rare three-piece tea set in the Prunus and Palm pattern (top center). The tumble-up set (top right) is scarce. (Bottom) An old-world styled, footed pitcher made only by D.F. Haynes in Baltimore.*

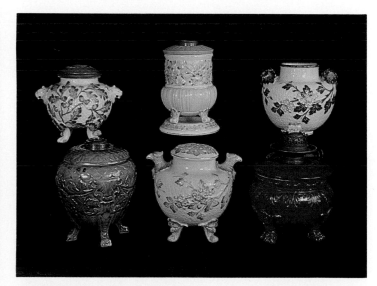

*A collection of rarely seen lamp bases and urns manufactured by D.F. Haynes, with the Avalon Faience stamp. The beige urn (bottom center) with its original, pierced lid for flower arrangements is rare. The lamp bases flanking the urn are rare examples of overall, monochromatic decoration (seldom utilized by the Baltimore firm).*

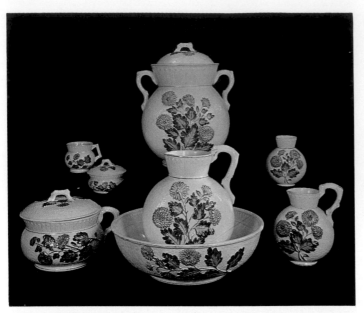

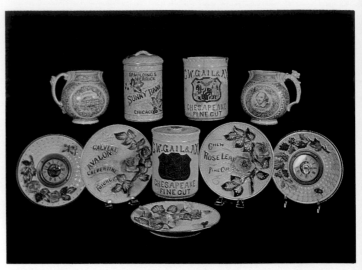

*A complete, Avalon-signed toilet set in the Chrysanthemum pattern. Only the Haynes Pottery offered the public such complete sets in majolica.*

*Largely a collection of advertising majolica made by D.F. Haynes on consignment for several tobacco firms. The jugs on either end at the top were ordered by John T. Ford of Ford's Theatre in Baltimore in 1892 for presentation by Julia Marlowe during a celebration of William Shakespeare's birthday. A thousand pitchers were potted for the occasion, each numbered and signed by Miss Marlowe.*

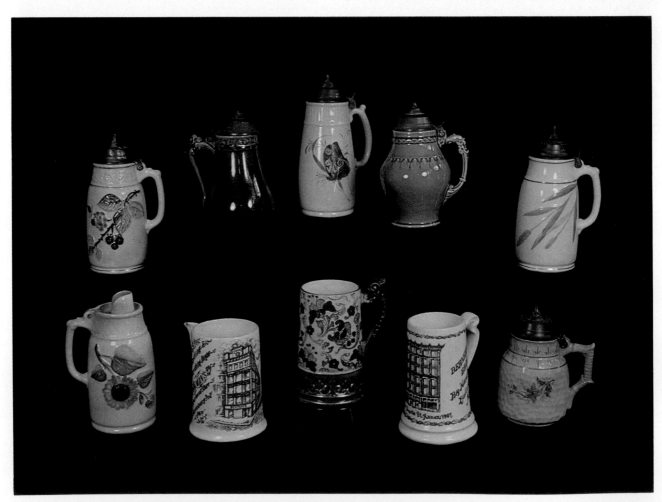

*A stein and syrup collection made by Edwin Bennett and D.F. Haynes of Baltimore. The syrups all bear the Bennett mark. The three steins (bottom center) are stamped with the Haynes signature.*

60

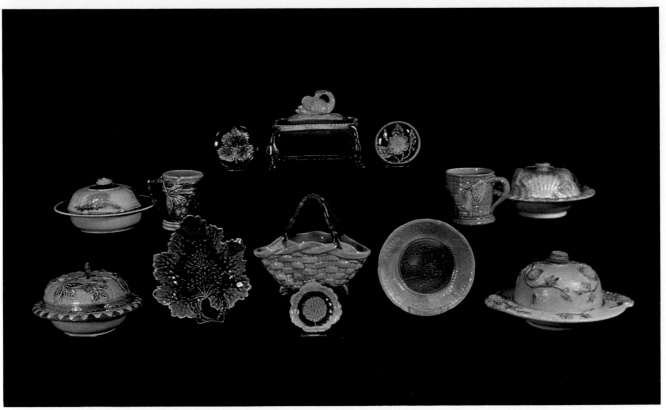

A selection of the New England Aster pattern attributed to James Scollay Taft and the Hampshire Pottery in Keene, New Hampshire. The pattern was available in complete dinner, tea and dessert sets. Most unusual is the spice tray with its rustic handle (bottom center). The two butter pats shown are the Sunflower pattern (bottom left) and equally scarce Aster pattern (bottom right). All pieces are unmarked.

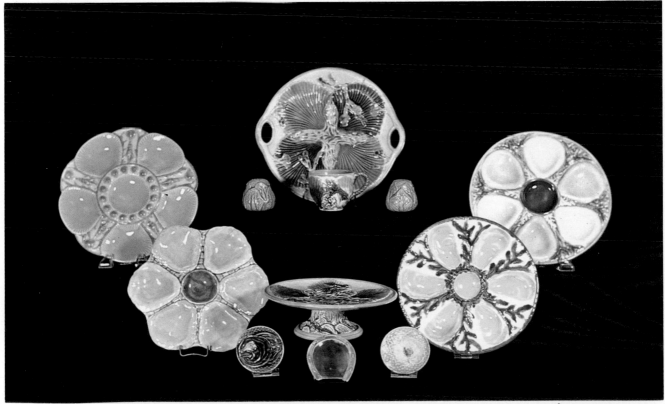

American, unmarked majolica. (Top, left to right) An American copy of the famous Minton oyster plate; a pair of Cauliflower salt and pepper shakers on either side of a large Shell and Seaweed serving tray attributed to James Carr and the New York Pottery Company; the cup in front of the tray and the pedestal cake stand are both in the Shell and Seaweed pattern and attributed to Carr. The remaining oyster plates are representative of the American potters. The finest of the group is on the bottom right.

61

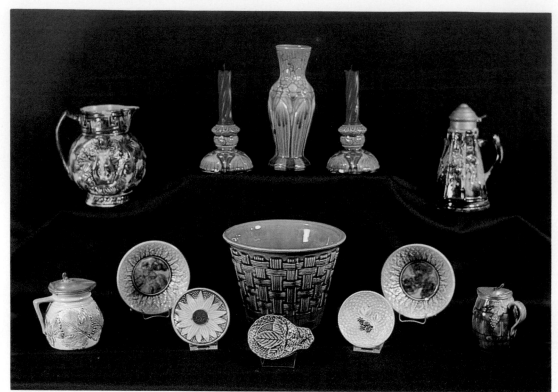

*(Top, left to right) A most unusual jug with Greek Key decoration around the neck and high-relief lyre and classical instruments on the body. The decorative treatment is typically New Milford, although unsigned, as is the pewter-topped syrup (far right). The Art Nouveau-styled candlesticks and matching vase, all in the Iris pattern, are attributed to the Hampshire Pottery Company. (Bottom, left to right) A syrup jug in the Fern pattern, scarce in this small size; a pair of Pineapple saucedishes flanking the signed Hampshire Pottery jardiniere with its Wicker styling. In front of the jardiniere are two butter chips and a spoon rest. On the far right is another small syrup jug in the Barrel styling.*

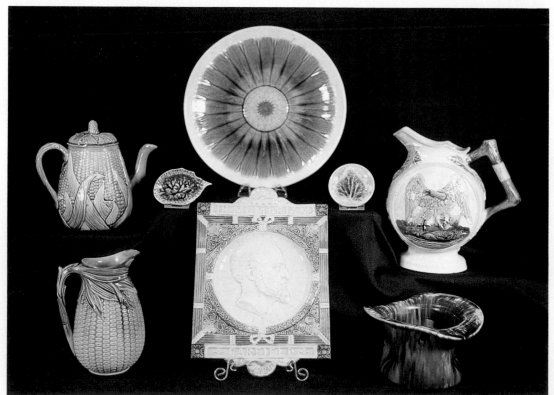

*A grouping of rare American majolica. (Top, left to right) The Taft-type Corn teapot; the Etruscan Begonia butter chip; the Etruscan Conventional or Cosmos fruit tray; the Etruscan butter pat in the Leaf-on-Plate pattern; a large pitcher combining the Begonia Leaf pattern with a vulturelike bird feeding on a smaller bird (on one side) and rabbit (on the reverse side). (Bottom, left to right) The Etruscan Corn jug; an elaborate plaque memorializing President Garfield; the New Milford Hat.*

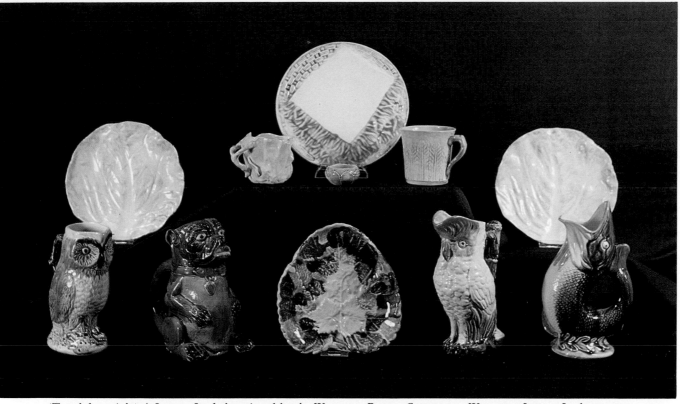

*(Top, left to right) A Lettuce Leaf plate signed by the Wannopee Pottery Company; a Wannopee Lettuce Leaf creamer with twin handles; a signed George Morley Napkin plate and individual salt dip in the Water Lily pattern, unsigned; an unsigned, Pineapple pattern mug generally attributed to the Etruscan potters; another Wannopee Lettuce Leaf plate. (Bottom) Figural jugs such as these are generally attributed to George Morley. The Pug Dog jug, however, is probably not a Morley creation, but definitely American. The center Leaf tray is signed "Morley & Co., Wellsville, Ohio."*

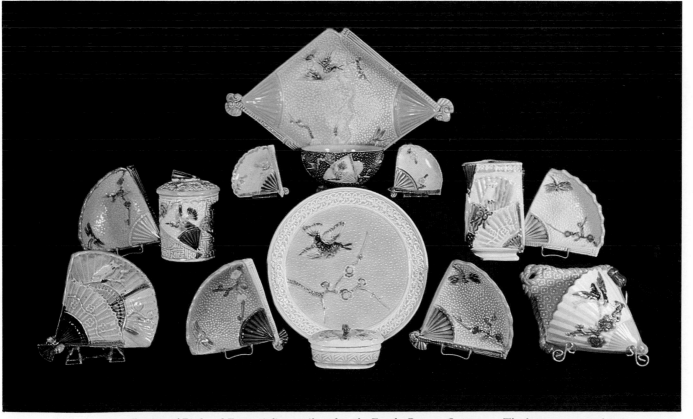

*A rarely seen collection of Bird and Fan majolica attributed to the Eureka Pottery Company. The bottom center plate is signed. While the remaining pieces are unsigned, the style, workmanship and weight clearly place them with the Trenton potters. The large angular platter (top center) is the ice cream serving tray which was potted as a set with smaller, fan-shaped individual ice cream plates. The even smaller, fan-shaped pieces are butter pats. The cigar humidor, the wall pocket flower holder (bottom right), and the matchbox (bottom center) are rare.*

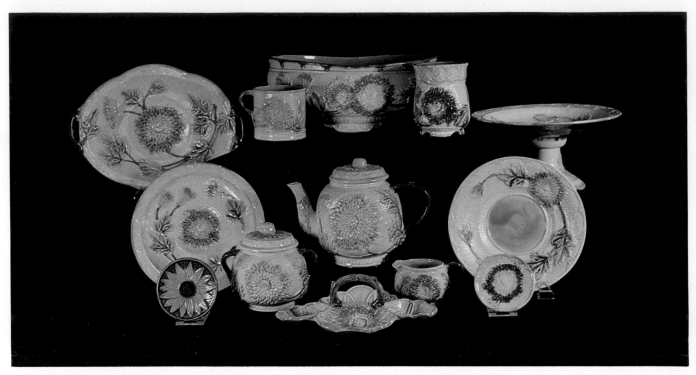

*An American collection of unmarked majolica. The lidded butter keepers on both ends of the array are quite popular. Most were potted with a removable insert for chipped ice. (Top center) A fine example of the American sardine box with swan finial and dolphin feet. The basket beneath the box and the butter (bottom right) are attributed to the Hampshire Pottery of J.S. Taft.*

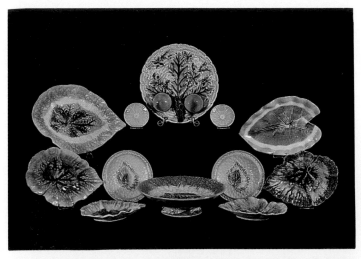

*The Begonia Leaf pattern initiated by the Etruscan potters. The signed Etruscan pieces are the yellow and green Leaf (top right), B-5, and the Standing Leaf (bottom left), B-12. (Top center) An unsigned, two-pocket, Strawberry server. The twin pockets were used to hold finely ground sugar. On either side of the server are two Pond Lily butter chips, unsigned.*

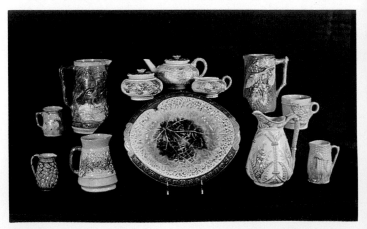

*A variety of unsigned American majolica serving pieces. The three-piece Geranium pattern tea set (top center) is rarely found complete. The small Pineapple creamer (bottom left) was made by the Bennington Pottery Company in Vermont.*

# 9 New Milford Pottery Company

In 1885, New Milford was a thriving Connecticut town, agriculturally oriented, but growing industrially as well. It may have been those growing pains that caused a small group of its citizens to join together to determine the feasibility of establishing a pottery to bolster and balance the town's economy.

After several months of meetings and negotiations, soil samplings and testings, plans were begun to establish a pottery. The group chose an advantageous site near the railroad that ran alongside the Housatonic River with ample leeway for the wagons that would soon be entering and leaving the new pottery grounds. All that was needed was money and someone who knew something about the manufacture of pottery.

To meet the financial challenge, the group set up a subscription program and offered shares in their project at $100 per share. In an amazingly brief time, the group had rounded up thirty-four subscribers who were willing and eager to share financially in the establishment of a town pottery. By June 1887, the group's goal of $15,000 had been reached, and six months later the legal documents were duly executed and recorded. The New Milford Pottery Company was ready to begin a building program.

It is interesting to find that among the thirty-four shareholders, a William Diamond Black was the only subscriber who was not a New Milford resident. He was a New York businessman who, together with Lewis F. Curtis, a local farmer and real estate operator, controlled ninety-one shares of the new venture, giving them indisputable, major control of the voting power of the new corporation.

The New Milford Pottery Company was indeed fortunate to acquire the skilled services of Charles Reynolds, a former designer for a Cleveland, Ohio, pottery, as their own chief designer and plant boss. Following Reynold's arrival, the company began operations, first producing white wares, cream-colored wares, and semiopaque china. Although the year was 1888, it was not too late to get in on the majolica craze.

From his very first potting of majolica, Reynolds thought "big." His huge Victorian umbrella stands, some taller than three feet, were among his initial introductions. These were followed by huge jardinieres, many with pedestals that gave them an impressive and grand appearance. Remember, however, that Victorian houses often were built with twelve- to fifteen-foot ceilings, so the umbrella stands and jardinieres could well afford to be tall, stately, and grand in appearance.

Although most of the before-mentioned items were not very ornate in design, they were important pieces of majolica. In keeping with his style, Reynolds designed a tubular, three-branch candelabra. Unfortunately, the two side arms of this rustic candelabra were placed at such severe angles that when the device was fully lighted, wax dripped down onto the base, causing disfavor with the public. It was soon discontinued.

Reynolds did become more ornate in his designing of gentlemen's spittoons, probably not with the farmers or local gentry in mind, but, perhaps, with the New York and Boston businessmen in mind, for his cuspidors were very elaborate in design. New Milford majolica was most frequently decorated by streaking or dabbing and dripping green, blue, and mauve paints over the entire body of the ware. A "top hat" planter or flowerpot, using this style of decoration, was unique to the New Milford firm. (See the color section.) Like all majolica potters of the time, Reynolds turned out his share of pitchers and milk jugs, as well as some tea, chocolate, and coffee sets, clock cases, and tablewares.

One of the most historical pieces made by the New Milford Company was the oyster white, sharkskin-textured "McKinley Pitcher." It was modeled with two differently designed handles and bodies — one straight-sided, and one bulbous — but with the same liquid capacity. Reynolds had this creation registered and patented in 1896, the year of William McKinley's election to the presidency. Tragically, President McKinley was assasinated on September 14, 1901.

At an unknown date, but probably around 1892, the New Milford Pottery Company met with some financial distress. Fortunately, in the shuffle that followed, the reorganization only brought about a change in the company's name. The former stamp of "N.M.P. Co." was replaced by the new "Wannopee Pottery Co." mark, usually reduced to an incised "W" within a sunburst design. On occasion, the old New Milford name was used with "New" placed above the sunburst emblem and "Milford" placed beneath it.

Probably as important as the reorganization of the company was the introduction of the Lettuce Leaf pattern to its line of majolica wares. Lettuce Leaf was originally a French design of the 18th-century faience potters, but Reynold's 19th-century version proved equally charming and very popular. In styling, the pattern appears to have been molded from actual leaves of the lettuce head, so close does it come to being truly natural. As the pattern was designed, the leaves overlapped around

bowls, teapots and cups, pitchers, and other hollow pieces. Twin handles were formed from small leaves of lettuce that joined at the base of the vessel. Such a design was unique among majolica potters. The plates consisted of a single leaf of the lettuce head.

By weight, Lettuce Leaf majolica is lighter than most other American majolica; and in appearance, it aesthetically seems far more delicate and dainty. The pattern was produced as a dinner service, a tea service, and in pitchers, mugs, and serving pieces. Lettuce Leaf proved to be Wannopee's biggest attraction.

After the liquidation of the New Milford Wannopee Pottery Company, the Lettuce Leaf pattern was continued by its creator when he moved to another pottery in Trenton, New Jersey. At this time, the mark changed from the sunburst "W" to a black "Lettuce Leaf" stamp, with the word "Trade" placed above the pattern name and "Mark" placed beneath it. All in all, Lettuce Leaf majolica is avidly sought after today by numerous collectors, and, in price, it is commensurate with the best of Etruscan and Chesapeake majolica.

In 1904, the plant was sold at public auction, and whatever stock remained in the warehouse was offered at public sale in New Milford. Unlike public auctions and sales today, the average price realized for the majolica sold ranged from $.03 to $.05 per item. One local concern, it is said, bought enough majolica that day to fill several barrels. Each lot was carefully packed and cushioned in straw within the barrels which were then placed in one of the firm's warehouses. Years later those same dusty barrels were discovered, examined, and promptly carted off to the town dump and discarded.

Fortunately for collectors and historians, alike, the New Milford Historical Society still cherishes its fine collection of majolica which is on display today at the society's headquarters in New Milford, Connecticut.

# 10 The Trenton Potters and Others

Documented information on the development of ceramics, especially majolica, in New Jersey is still a wide-open field, and the 19th century remains very much virgin territory for the scholar. We do know that clay deposits were discovered in the vicinity of Trenton, New Jersey, as early as 1852. Among the first potters to locate in that area were Messrs. Taylor and Speeler who began operations there with the manufacture of yellow and Rockingham-type wares.

While kaolin and feldspar were not available locally, the cost of bringing in such essentials from Delaware and Pennsylvania was offset by the availability of shipping routes along the ever-expanding Delaware and Chesapeake canal system, and by excellent docking facilities along the Delaware River at Trenton.

By the 1870s, the area had grown into a pottery center, thanks to the emigrant Irish, French, German, and especially, the English potters who chose the Trenton area as a base for their operations. Here the three Willet brothers and the partnership of Ott and Brewer developed a Belleek ware to rival their Irish contemporaries. Others like John Moses, James Tams, W.S. Hancock, and J. Hart Brewer specialized in cream-colored wares, hotel and steamboat china, as well as in white granite dinner and toilet wares. Several other potters entered the field of art pottery, faience, and majolica. The Trenton group flourished, and, by the 1890s, the area had grown to such proportions that it was nicknamed the ''Staffordshire of America.''

At the Centennial Exhibition in Philadelphia in 1876, many of these potters displayed their wares publicly; and for the first time, the public and the potters themselves were able to view the accomplishments of the emerging American pottery business, as well as its foreign competitors. Comparisons were made, judges rendered decisions, medals were awarded, and, in the case of most American potters, new directions began to take shape. Future pottery operations became the topic in many business discussions.

A few of the majolica potters, whose wares were marketed unmarked, received national recognition for their individual work at the Philadelphia Exhibition; but, unfortunately for the ceramics scholar, those same potters continued to market their wares thereafter without the addition of recognizable stamps or marks. Consequently, identifying the Trenton potters and their wares today remains somewhat an educated guessing game.

From the registered entries at the Centennial Exhibition, it is safe to state that the Glasgow Pottery of Trenton, which was also a contracting pottery for various crockery outlets along the East Coast, entered a display of largely utilitarian majolica. Because the firm was a contracting pottery, its majolica, naturally, was left unmarked so that crockery dealers could apply their own labels to the wares at the time of resale.

# Eureka Pottery Company

The Eureka Pottery Company of Trenton produced much distinctive majolica, specializing in an Orientally inspired pattern called Bird and Fan, which was made available in a dinner service, a dessert service with cake stand, variously shaped pitchers, tobacco and cigar humidors, and in complete ice cream sets. Another majolica pattern favored by Eureka was that of a stork wading in a marsh-lined pond surrounded by cattails, all molded in high relief. Although Eureka rarely marked its wares, when it did it was with the company's name impressed, along with the town, Trenton, beneath it.

The Crown Porcelain Works, operated by Messrs. Barlow and Marsh, also displayed some of their majolica and faience as a specialty to accompany their regular line of better-known porcelain wares.

The Arsenal Pottery, owned by the Mayer Pottery Manufacturing Company (Joseph H. Mayer, proprietor), produced much majolica, but marketed most of it unmarked. Mayer exhibited a selection of finely modeled majolica Toby jugs and pitchers, imitative of earlier English designs.

From nearby Woodbridge, New Jersey, Clara and H.A. Poillon, who specialized in garden pottery with the customary high-relief moldings and majolica glazes, entered an exhibit of their work. The Poillons, however, devoted most of their potting efforts to the production of art pottery, for which they are most remembered today.

According to Edwin Atlee Barber in his book, *The Pottery and Porcelain of the United States,* the Willets Manufacturing Company of Trenton, eminent today for their fine line of American Belleek, also potted majolica, although such wares were marketed unmarked by the firm.

# Philadelphia

The Philadelphia City Pottery belonged to J.E. Jeffords, who began potting in 1868 in Philadelphia. He first learned his trade while serving an apprenticeship under Carr and Morrison at the New York City Pottery.

Jeffords exhibited some of his majolica in 1876 at the Great Exposition, which places him among the earliest of American majolica makers, even though very little of his work bears his mark. From registered entries in the exhibition, it is known that he potted a variety of large majolica jardinieres and stands, along with several colorful teapots, all done in high relief and with lustrous glazes.

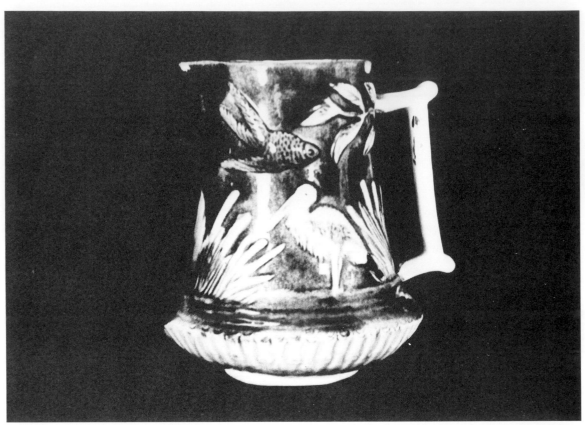

*An unmarked stork jug similar to those potted by the Eureka Pottery Company, Trenton, New Jersey. Decorated largely in dark browns and bright yellows. The stork is pink-breasted, while the fish and cattails are in variegated greens.*

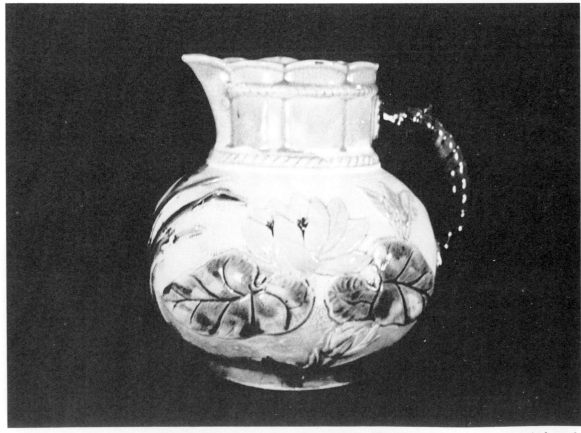

*A turquoise, white, and yellow bulbous jug in the Water Lily pattern. The rope-twist trim adds a nautical touch. Unsigned.*

# Tenuous Majolica

At a quick glance, the beginning collector who spies the Tenuous majolica mark for the first time may immediately conclude it to be that of Etruscan—the circled monogram of Griffen, Smith, and Hill. But, upon closer inspection, he will decipher the impressed mark to read "Tenuous Majolica," incised inside a pair of rings. A smaller "H" was then positioned inside a tiny circle dead center. This smaller mark may well be the key to the identity of this anonymous American potter. Thus far, no scholar has come up with a bona fide confirmation. What a shame! Certainly the potter knew his trade, for his wares are attractive, delightfully colorful, and well-glazed.

In his leaf-shaped butter pats and trays, the potter was quite original, avoiding the much-copied begonia leaves made famous by Griffen, Smith, and Hill in Phoenixville. The Tenuous version is much more stylized, almost neoclassic in design. The trays were tapered and provided twiggy thumb grips, suggesting that they were intended for serving sweetmeats, or for calling cards so necessary to the social etiquette of Victorian society.

To date, all that is known of this potter is that he generally marked his wares, which the collector will find a rarity. Tenuous majolica deserves inclusion in every American majolica collection.

# New York Potters

An entire chapter has already been devoted to the work and accomplishments of James Carr and the New York City Pottery, but several other potters in New York should be noted.

## J. BENNETT N.Y.

### John Bennett

John Bennett came to America in the 1870s from England where he had been a director in the faience department of the Lambeth Pottery of Doulton and Company in London. He settled in New York City where he introduced his style of decorating faience under the glaze. Using imported English biscuit ware first, but later turning to Trenton-made biscuit, he created some of the finest decorative wares to be found.

He most often worked with simply shaped vases and urns, devoid of handles or molded ornamentation. Painting with minimal touches on dark backgrounds, he achieved great artistic grace in his detailing of flowers and foliage, done in delicate tints, boldly outlined by the depth of the background. His style was at once both ornately naturalistic, yet artistically simple. His creations were much sought after by the public even though his prices were considered expensive for the late Victorian period. His wares were much imitated, but never equaled in finesse.

### Odell and Booth Brothers

In Tarrytown, New York, Odell and Booth began potting operations in 1878, offering the public a line of majolica wares, as well as the then-popular faience pottery. Their business venture covered only a few short years, and little is known of their specific patterns. It is assumed they sold their majolica unmarked. Perhaps later, researchers will be able to inform us better of their place among American majolica makers.

## FMC°

### Faience Manufacturing Company

In 1880, near Greenpoint, Long Island, the Faience Manufacturing Company began operations that continued throughout the decade. Although the firm favored art pottery, majolica was included in their first line of wares. Authorities assert that the company produced some of the finest artistic wares ever produced in this country. Their wares were original in design and handsomely decorated by the best artists of the day. An incised trademark, composed of the initials of the company — FMC — was used to mark their majolica.

Edward Lycett served as superintendent and principal decorator for the firm. Most of the credit for its success has been attributed to him. Several vases in white faience, decorated with brilliantly colored birds and foliage and trimmed in raised gold, are known to exist in private collections.

# Miscellanea

If the clay could talk, it might tell us much that should be written about the myriad potters whose diverse majolica wares fall so conveniently into a catchall grouping; but, for lack of factual information, mysteries remain. Certainly by the end of the majolica period, the pottery business stretched as far west as the Stockton Art Pottery Company in Stockton, California, and southward into New Orleans and Mississippi. Wherever nature provided a suitable clay, the potter found his way; and together, man and nature provided us with the utensils and artistic creations that the collector now cherishes as the bond between yesterday and today.

Just how many potters lived and died unnoticed and unnoted is not known, but their number must be legion. America was blessed with a multitude of potters who never achieved fame or fortune, but who labored with the clay and offered the public the best that they had to give. Today their wares brighten the lives and the homes of the American collector, and, in their way, provide each of us with the roots we search for in identifying who we are as a people and a nation.

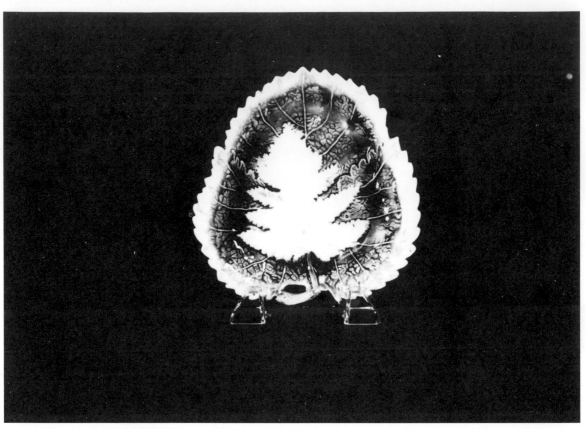

*An ice blue and snow white leaf tray, most likely made as a calling-card tray or candy dish.  Unmarked.*

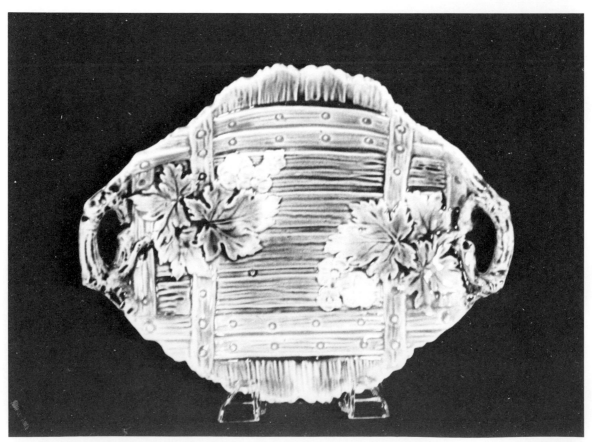

*A rustic fence, small platter with twig handles.  Overall, a blend of summer green and turquoise with pink tinted blossoms.  Unsigned.*

74

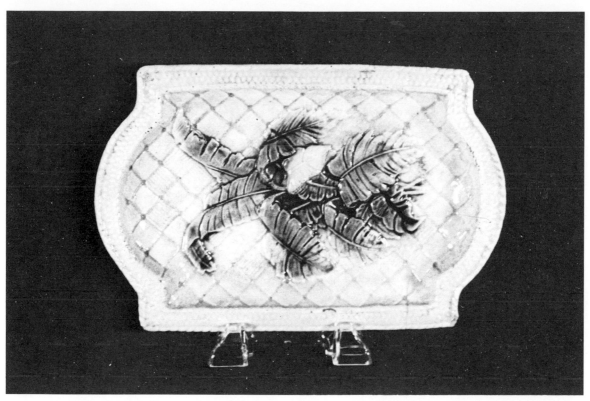

*A turquoise-bordered, small platter, with wind-blown tropical leaves over a fishnet base in antique yellow. Unsigned.*

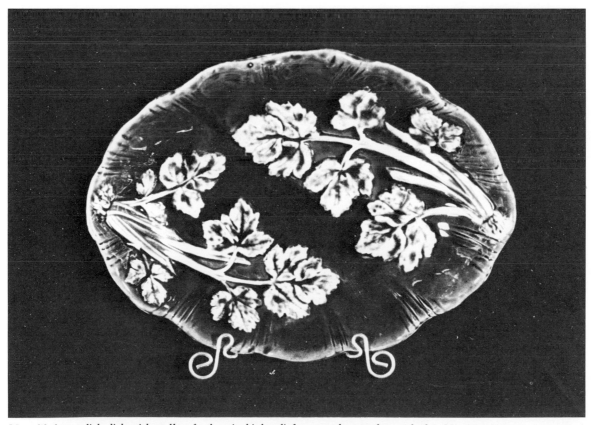

*Most likely a relish dish with stalks of celery in high relief over a chestnut-brown body. No signature.*

*Four examples of the Pineapple pattern. Potters unknown. This pattern was also popular in a dinner and tea service.*

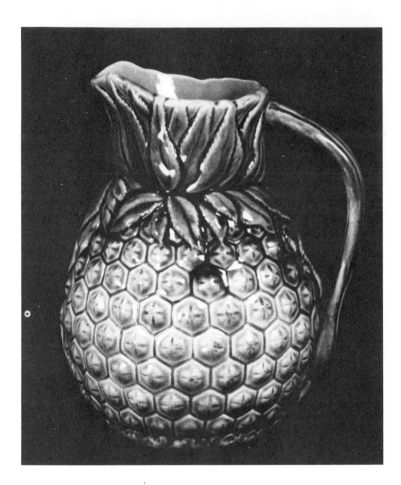 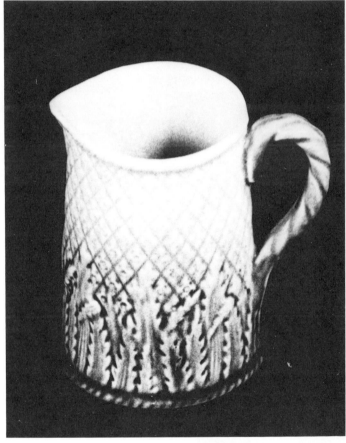

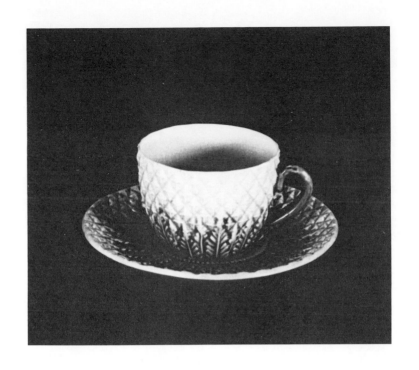

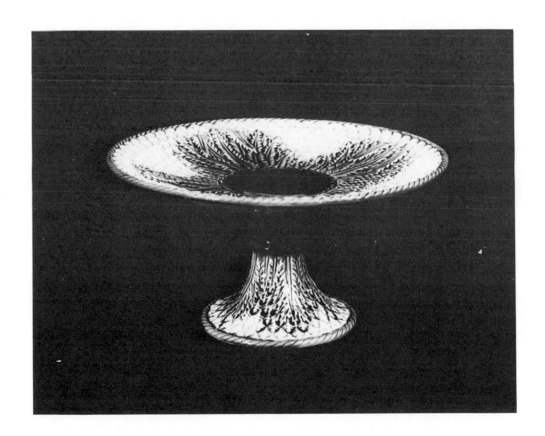

*A rare, historical plaque commemorative of our 20th president who was assassinated after only four months in office. The laurel wreath, acanthus, and shell trim are symbolic of the honor in which the president was held. Potter unknown.*

*An outstanding example of the elegant Victorian umbrella stand. This one was decorated in sienna brown, with high-relief leaves, and flowers in pale pinks and autumn colors. Unmarked.*

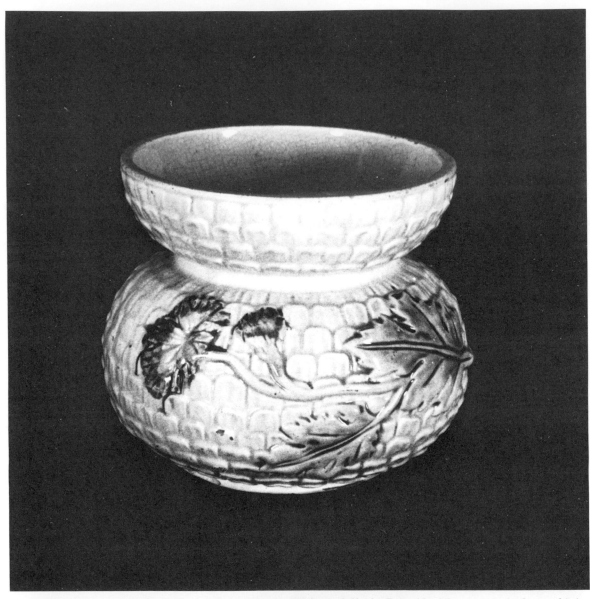

*A gentleman's spittoon, similar to those potted by George Morley and Charles Reynolds. The pinecone background is in yellow ocher. The sprig of wild aster is bright red. Pink-washed interior. No mark.*

# 11 In Retrospect

The American potters of the last half of the 19th century were largely a heterogeneous group of emigrant English, Irish, and Europeans who chose to discover for themselves the opportunities that might await them in this country. Except for a handful of majolica makers like James Taft of New Hampshire, Messrs. Henry and George Griffen of Pennsylvania, and David Francis Haynes of Maryland, the remainder were predominately adopted Americans who had brought with them the skills and the techniques of their trade. The modeling and styling of American majolica was, therefore, in its early days, reflective of the ethnic backgrounds of this cross section of the new America.

In Europe and in England, the pottery business had been a long-established enterprise with fully developed clay and mineral mines and advanced techniques in glazes, bodies, and decorations. Here in America, the last half of the 19th century proved to be a search and trial period for the emerging potter. Sources of suitable clay needed to be found and developed, feldspar and kaolin required mining, roads had to be built, and land had to be cleared before the first kiln could be built and the first majolica fired.

As these basics were being developed, the American potter realized that he had a great deal of catching up to do before he could make even one small wave in the potting pond. And, when he had finally succeeded in firing his first piece of majolica, he found middle-class America already hooked on English and European imports. Public taste, it seems, favored English majolica as the refinement of Victorian taste in the late 1800s.

Consequently, the American potter of that period was required to be imitative rather than creative if he were to sell his wares. Fortunately, many of them had learned their craft in such venerable potteries as the Wedgwood Etruria Works and in those of Herbert Minton in Stoke on Trent, England. So, our emigrant potters repeated in clay what they had seen, potted, and created in their homelands. Their output was marketed without identification purposefully; for in so doing, the buyer could not know whether he was purchasing an American-made or an imported ware, as each looked alike.

Our early potters earned a meager living; but, in the case of our most promising artists, like James Carr of New York and Edwin Bennett of Maryland, a few were able to earn enough to attract and employ the best young decorators and creative assistants. Together, they experimented in improving and refining their wares until American majolica became the recognized equal of any of its foreign competitors.

With the true awakening of interest in majolica, stirred by the Centennial Exhibition of 1876, the American potter grew intensely aware of his competition and the aesthetic, new trends in earthenware designs. The English and the

Europeans came to Philadelphia that year and set up their displays of earthenwares and porcelains beside those of our own potters, and, with the exception of a choice few, it was fully apparent that the American potter had much to learn.

In the Great Exhibition, the English dominated the scene. It was they who introduced America to the new styling in majolica. They elevated majolica out of the utilitarian, mundane, and drab, into the beautiful. Most of the western hemisphere nations were bogged down in the ugliness and sordidness of sweatshops and middle-class poverty. The new, aesthetic movement lifted the darkness and oppression from man's spirit, for suddenly there was beauty in the everyday dinner plate, in the morning milk pitcher, in the smallest calling-card tray.

The resurgence of the Oriental trend which had been revitalized in the London International Exhibition of 1862 was in evidence. The ageless prunus and cherry blossom, the fan, the iris and bamboo began to appear in America on the majolica wares of the English potters. The wicker and basket weave backgrounds utilized by the English in their potting of tea sets and dinnerwares were an offshoot of the wicker and rattan-styling in country furniture already popular both here and abroad. Such innovative ideas and trends opened the minds of American potters to opportunities unrealized before.

The Etruscan potters in Phoenixville were swift to incorporate these new influences into the designing of their Orientally inspired Bamboo tea set and luncheon service in majolica. The asymmetrical form and simplicity of the orient again appeared in the firm's introduction of their Bird and Bamboo tea set, as well as in their styling of the Iris and Bamboo molasses jug.

The Eureka Pottery Company of Trenton carved a unique niche for itself in the potting of their Prunus and Bird, and Bird and Fan collections of majolica serving pieces. Majolica became decorative as well as useful, and the public clamored for more of it. David Francis Haynes in Baltimore certainly exemplified the aesthetic movement in his Clifton and Avalon majolica, as well as adding the refinement and aura of old-world classicism.

Riding the crest of the aesthetic trend came the elevation of nature to new heights through the incorporation of the Victorian fancy for potted plants of both the exotic and ordinary varieties. Patterns such as Pineapple, Cauliflower, Sunflower, Wild Rose, and Woodland Fern became immediate successes. Certainly the prolific production of the Begonia Leaf pattern by Griffen, Smith, and Hill in their leaf-dish series is but another symbolic example of that firm's success.

Like subjects were utilized by nearly all of the Victorian potters. The simple, natural beauty of plant culture offered the public a ray of sunshine, a gleam of hope. Even though such patterns as Pineapple and Cauliflower were anything but new to the artist or the potter, the timely reintroduction of such plants, fruits, and flowers into majolica patterns provided colorful and satisfying subjects for the potter and the public alike.

The human figure rarely appeared in American majolica but was espoused by the Minton, George Jones, and Wedgwood potters in England. The figures of children and cupids predominated many of their masterpieces. Except for the Etruscan potters who minutely copied an earlier Wedgwood pitcher or tankard, substituting

two baseball players for two of the English cricket players in the design, few American potters found the human figure a fitting subject for their majolica.

American potters did rally around the seashell and dolphin motifs. Although James Carr in New York introduced the American version of the earlier Wedgwood Shell and Seaweed pattern as early as the 1870s, it remained for Griffen, Smith, and Hill in Phoenixville to elevate this pattern to its finest achievement in the 1880s. George Morley in Ohio favored the dolphin and the fish in his potting of majolica, as did the Etruscan potters. The romance and mystery of the sea have always appealed to man's imagination, and such nautical subjects provided a tremendous surge of interest in majolica wares.

During the Victorian period, originality never seemed to be of prime importance or a virtue among American artisans. No one hesitated to create exact copies of the most sought after wares, which included the English as well as the American. What was of prime importance to every potter was meeting the competition and remaining solvent in business. It was not until the establishment of schools of industrial design and art in America that truly creative designing and modeling positioned America within the leadership of the international ceramics industry.

Today we are privileged to look back over a century of pioneering, progress, and plagiarism. American majolica was a part of that dynamic period, which, with all of its faults, has provided us with a multitude of fine antiques for today's collector. Majolica may be prized for many reasons, but none more evident than its natural whimsy and its exuberance of living colors. As majolica once brightened the everyday lives of our forefathers, may its presence today light up our own darkest days and help us realize that somewhere an unknown potter labored not in vain, but for posterity.

# Bibliography

Barber, Edwin Atlee. *The Pottery and Porcelain of the United States.* 3rd Edition. New York: G.P. Putnam's Sons, 1909.

Clover, Marian. "Ceramic Museum Opens." *Ohio Motorist Magazine,* April 1980.

"Colony House Museum." Reprinted from *New Hampshire Profiles.* Hanover, N.H.: Colony House Museum, 1975.

Cox, Warren E. *The Book of Pottery and Porcelain.* Vol. 2. New York: Crown Publishers, Inc., 1970.

Fitzpatrick, Paul J. "Chesapeake Pottery." *The Antiques Journal,* December 1978.

Freeman, Larry. *China Classics. 1. Majolica.* Watkins Glen, N.Y.: Century House, 1949.

"George Morley, Pioneer Pottery 1870-1900." East Liverpool, Ohio: East Liverpool Museum of Ceramics.

"Griffen, Smith and Hill Company." *National Antiques Review,* October 1971.

Hartman, Urban. *Porcelain and Pottery Marks.* New York: privately printed, 1943.

James, Arthur E. *The Potters and Potteries of Chester County, Pennsylvania.* Exton, Pa.: Schiffer Publishing Co., 1978.

Pappas, Joan and Kendall, A. Harold. *Hampshire Pottery Manufactured by J.S. Taft and Company, Keene, New Hampshire,* Manchester, Vermont: Forward's Color Productions, Inc., 1971.

Peck, Harold. "The New Milford Pottery Company and/or Wannopee Pottery Company." Unpublished manuscript. New Milford, Conn.: New Milford Public Library.

Rickerson, Wildey C. *Majolica — Collect It for Fun and Profit.* Chester, Conn.: Pequot Press, 1963.

Scavizzi, Guiseppe. *Majolica, Delft and Faience.* London: Hamlyn Publishing Group, Ltd., 1970.

Stern, Anna. "Majolica — Flamboyant Victorian Ware." *The Encyclopedia of Collectibles.* Alexandria, Va.: Time-Life Books, 1979.

Thorn, C. Jordon. *Handbook of Old Pottery and Porcelain Marks.* New York: Tudor Publishing Co., 1947.

"Upper Ashuelot — A History of Keene, New Hampshire." Keene, N.H.: Keene Public Library, 1968.

Weidner, Brooke. *Catalogue of Majolica 1884.* Reprint. Phoenixville, Pa.: Brooke Weidner, Publisher, 1960.

Weidner, Ruth Irwin. "The Majolica Wares of Griffen, Smith and Company." *Spinning Wheel,* January-February, 1980.

———. "The Majolica Wares of Griffen, Smith and Company." *Spinning Wheel,* March-April, 1980.

# Index

# About the Author

M. Charles Rebert is a native Pennsylvanian and a graduate of Western Maryland College where he earned his bachelor's degree in English and history. Upon graduation from college, he enlisted in the Army Air Force and served for three years as a communications sergeant with the 69th Airdrome Squadron.

Following his discharge from the service, he entered the Wilshire School of Broadcasting in Los Angeles. His first assignment after graduation was with the Mid-South Radio Network, headquartered in Columbus, Mississippi. His initial duties there included both staff announcing and copy writing before he advanced to program director and feature writer-producer.

In the early 1950s, Mr. Rebert switched careers and accepted a position with the Atlantic Richfield Oil Co. in Philadelphia as a statistical analyst in the economics department. It was while he was in Philadelphia that Mr. Rebert wrote his first book, *Shadow Prints,* and began a part-time career as instructor in creative writing and poetry with the St. Davids Writers' Conference, Eastern Baptist College, St. Davids, Pennsylvania, a position he held until 1973.

Since 1960 Mr. Rebert has been a freelance writer, high school journalism and creative writing teacher, and author of five more volumes of poetry and numerous short stories. During the 1960s and 1970s he was the recipient of numerous awards, including the national Dion O'Donnol Award, the International Poetry Award from *Vagabond* Magazine in Munich, Germany, and the Medal of Honor in Belle Lettres from the International Writers' Academy in Rome. A further resume of Mr. Rebert's writing career may be found in the Marquis *Who's Who in the East,* 16th Ed., and in the *Writers' Directory,* St. Martin's Press, New York.

Mingled with Mr. Rebert's professional life as writer-teacher has been his avid interest in antiques, especially American majolica. For the past ten years he has been both a collector and a dealer in antiques, specializing in American and English majolica.